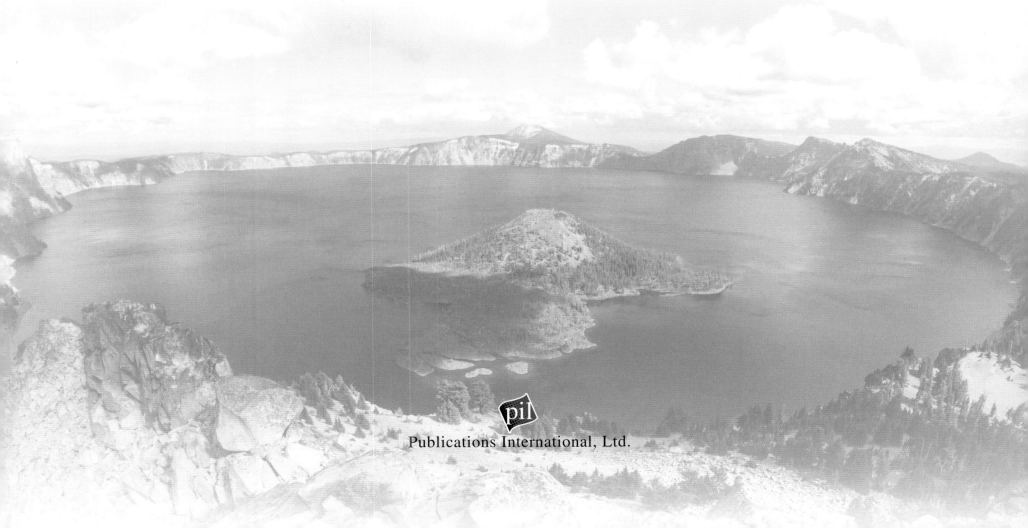

AMERICA'S
BEST ISLANDS

OVER 70 OF THE GREATEST GETAWAYS IN THE USA

pil

Publications International, Ltd.

Contributing writer: Marty Strasen

Cover and interior images: Shutterstock.com

Louis Weber, CEO
Publications International, Ltd.
8140 Lehigh Avenue
Morton Grove, IL 60053

ISBN: 978-1-64030-877-0

Manufactured in China.

8 7 6 5 4 3 2 1

TABLE OF CONTENTS

Places Set Apart

Islands, large or small, rugged or idyllic, represent something separate, self-contained, and a little mysterious. It takes extra effort to get there—effort that is sometimes part of the adventure itself. Once there, the reward is immediately apparent. Islands are at a remove from the rest of the world. The chatter from across the water is muted. With outside distractions at a distance, it's easier to relax. Days even seem to pass according to a different clock—"island time" is that feeling of moving to rhythms that are more natural and less hectic that those of the mainland.

While islands all share a special separateness, they also assert an intrinsic individuality that makes them especially loved by artists, writers, photographers, eccentrics, and free spirits of all stripes. *America's Best Islands* takes a look at some of these notably unique places. We begin with the rocky beaches of New England and move down the coast, exploring urban oases and barrier islands. Next, Florida and the Gulf's

vacation paradises, with their endless beaches and turquoise waters. We discover both urban and wilderness gems in the Great Lakes and further inland. We explore the Pacific Coast, from California to Alaska. Finally, we take in a smattering of some of the best U.S. ocean islands, both in the Caribbean and the Pacific. We visit over 70 islands—from luxurious, resort-like locations to truly pristine places where human footprints are rarely seen. Whether you're an armchair tourist or on the lookout for more destinations to add to your bucket list, *America's Best Islands* is a beautiful collection of delightfully unique places set apart.

BAR

There's just enough time to add your own contribution to a cairn garden before the tide comes in.

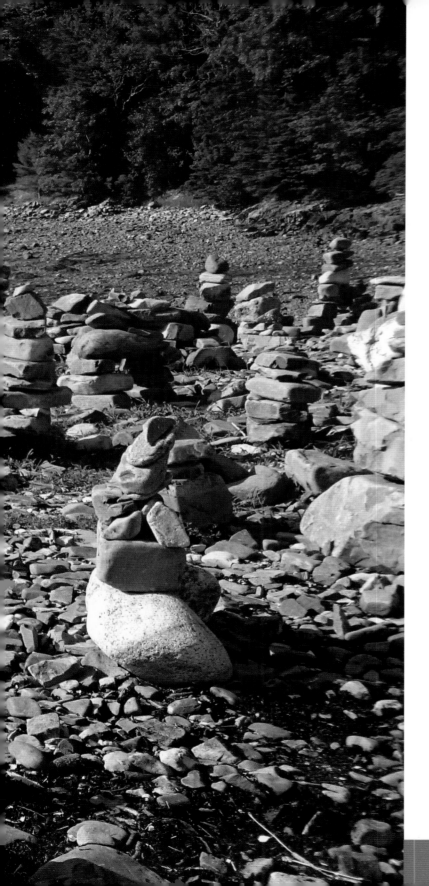

Bar Island

SIZE: 0.5 MILES LONG

LOCATION: BAR HARBOR, MAINE

ACCESSIBILITY: BOAT OR WALKING (AT LOW TIDE) ON GRAVEL LAND BRIDGE

Bar Island is a treasured slice of Acadia National Park, located due north of the West Street town pier in Bar Harbor, Maine. At low tide, visitors can walk about a half mile from the mainland to the island on a natural gravel land bridge. Some park their cars on the sand bar before walking over, but the return of high tide can make that a dangerous proposition. Once on the island, visitors enjoy spectacular views and a wonderful hiking trail.

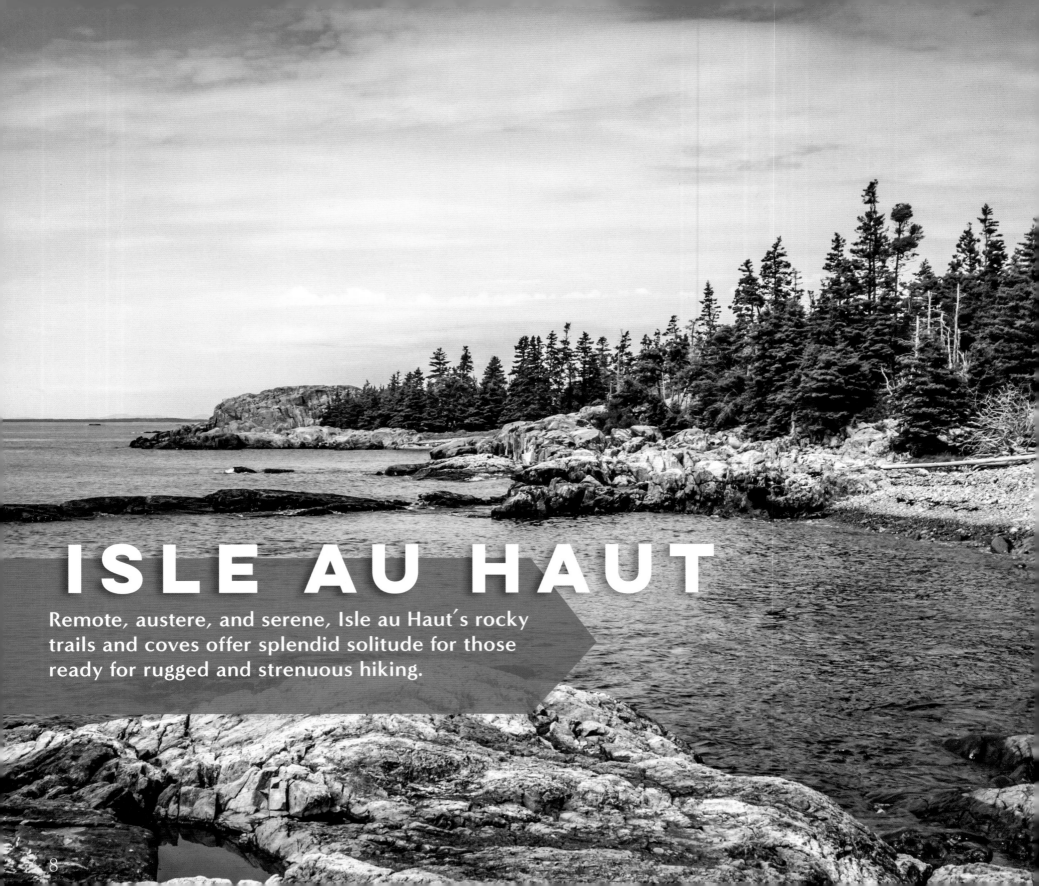

ISLE AU HAUT

Remote, austere, and serene, Isle au Haut's rocky trails and coves offer splendid solitude for those ready for rugged and strenuous hiking.

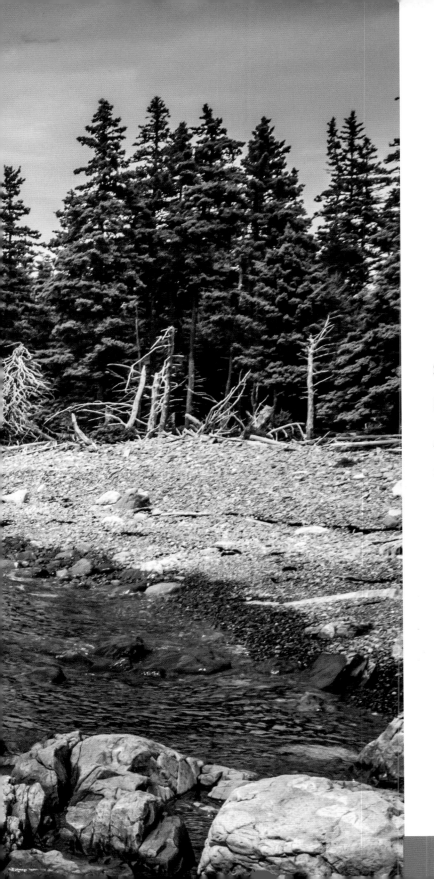

Isle au Haut

SIZE: 12.5 SQUARE MILES
LOCATION: KNOX COUNTY, MAINE
ACCESSIBILITY: YEAR-ROUND FERRY SERVICE

Fewer than 100 people live in the town of Isle au Haut on the island of the same name in Penobscot Bay. The island includes portions of Acadia National Park and is popular for hiking, fishing, bicycling and camping, but be aware: the number of visitors to the island at any one time is limited. About half of Isle au Haut consists of federal park land, while the other half is privately owned.

MONHEGAN

The tiny harbor village is surrounded by rocky hills, woods, trails, and crashing surf. The amenities are sparse, but the forest trails and ocean views offer a quiet escape from the busy world.

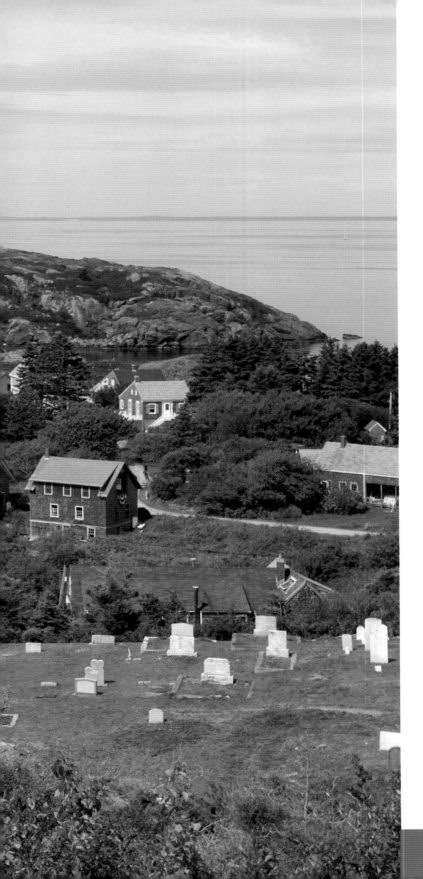

Monhegan Island

SIZE: 0.9 SQUARE MILES

LOCATION: LINCOLN COUNTY, MAINE

ACCESSIBILITY: ONLY BY BOAT

The peaceful beauty of its wilderness has made tiny Monhegan Island a favorite of artists and anyone looking to get away from it all. It touts a "simple, friendly way of life" both for those visitors and the 60-some residents of the island. Though the island measures less than one square mile, more than 12 miles of beautiful (and some rather strenuous) hiking trails wind through its wilderness areas.

MOUNT DESERT

On the island's eastern side, the rocky Beehive trail climbs to Beehive Summit, rising 520 feet above the surrounding terrain.

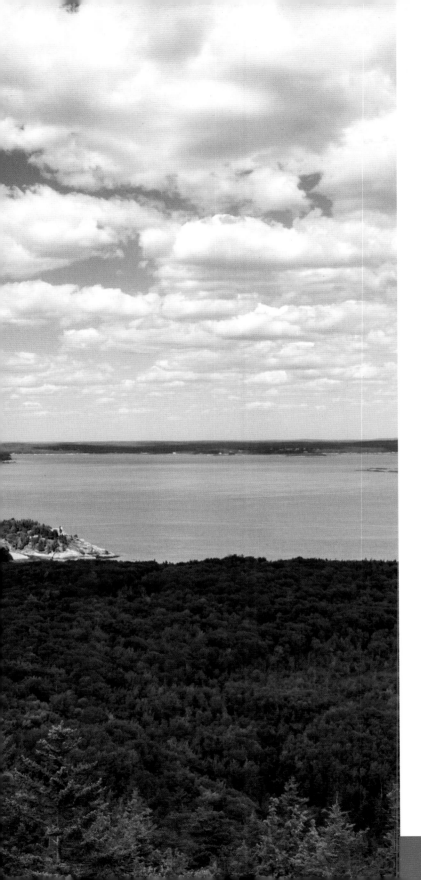

Mount Desert Island

SIZE: 108 SQUARE MILES

LOCATION: HANCOCK COUNTY, MAINE

ACCESSIBILITY: AIRPLANE, BOAT, OR CAR

Home to beautiful Acadia National Park and the oft-visited town of Bar Harbor, Mount Desert Island is the second-largest island on the eastern seaboard (after Long Island, NY). It's home to a smattering of the country's rich and famous, and a popular summer destination for tourists who come from all corners to enjoy spectacular sweeping cliffs, mountain views, and the restaurants and shops of quaint harbor towns. Hiking, biking, and water sports of all kinds are among the most popular activities on this renowned hot spot.

GREAT CRANBERRY

SIZE: 2 SQUARE MILES

LOCATION: TOWN OF CRANBERRY ISLES, MAINE

ACCESSIBILITY: FERRY

Great Cranberry is a classic New England island, with quiet forest trails and deserted rocky beaches.

Great Cranberry Island is the largest of the Cranberry Isles, part of Acadia National Park. A peaceful respite from the relative bustle of Mt. Desert Island, Great Cranberry offers some of the most breathtaking views of the national park, its mountains, and the Bear Island Lighthouse. Most of the year-round residents on Great Cranberry Island are in the fishing and lobstering business, but the summer months bring visitors from all over to enjoy a history museum, gift shops, and hiking and biking trails.

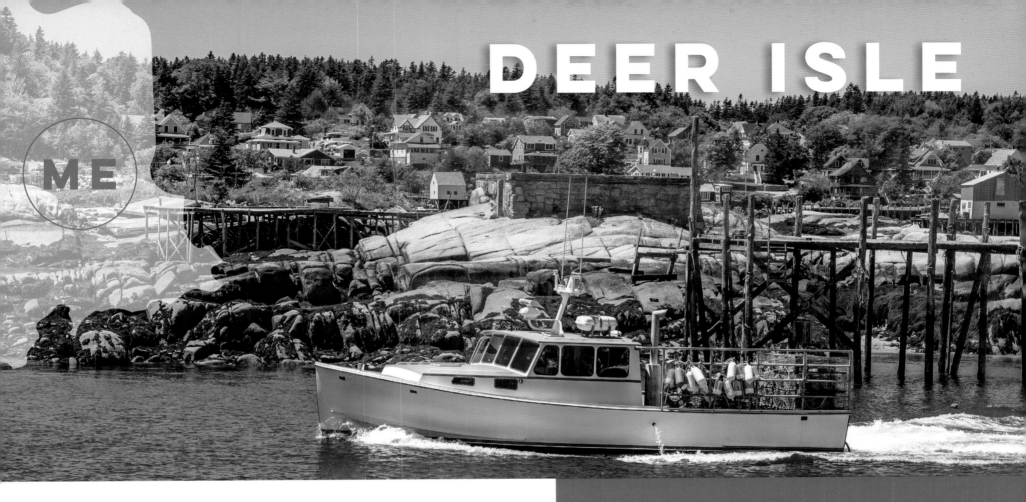

DEER ISLE

SIZE: 30 SQUARE MILES
LOCATION: PENOBSCOT BAY, MAINE
ACCESSIBILITY: CAR OR BOAT

Lobstering and tourism are a big part of the local economy. The fresh-caught lobster of Deer Isle is considered some of the best in the world.

Almost as soon as the car drives off the bridge from the mainland onto Deer Isle, those in the vehicle are transported back in time to mid-20th century New England. Or, perhaps, to the scene James Rosier encountered when he sailed from England in 1605. Much of the island is unspoiled and looks untouched, as Rosier would have found it. And much is idyllic, as though it's the '50s all over again. There are galleries and studios all over the island, testament to the rich community of artists who call it home. More than a dozen nature conservatories help to make Deer Isle a paradise for photographers, bird-watchers, and hikers.

NANTUCKET

Once the whaling capital of the world, Nantucket harbor is now a tourist mecca, with over 50,000 inhabitants in the summer.

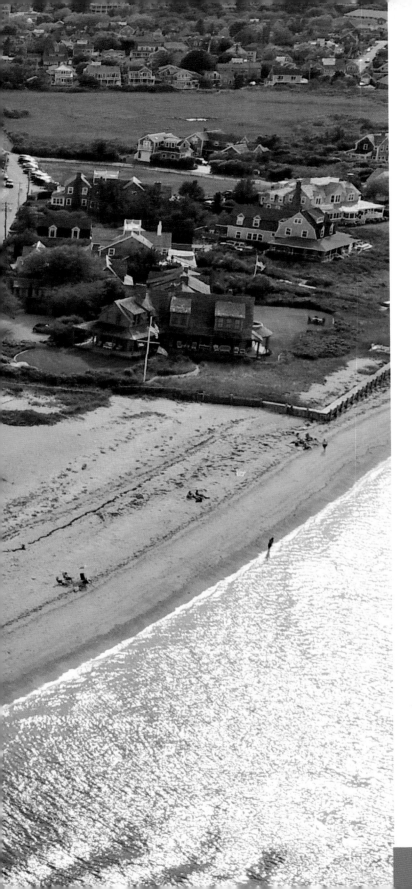

Nantucket Island

SIZE: 48 SQUARE MILES

LOCATION: SOUTH OF CAPE COD, MASSACHUSETTS

ACCESSIBILITY: AIRPLANE OR BOAT

National Geographic once called Nantucket "the best island in the world." From those who have visited once to the many who make annual pilgrimages, there would be considerable agreement. Nantucket was honored as a National Historic Landmark in 1966 as the "finest surviving architectural and environmental example of a late 18th- and early 19th-century New England seaport town." There are activities galore (no camping, though), including boat tours, lighthouse viewing, and a whaling museum. Cars were banned on the island in the early 20th century, and bicycles are still the preferred form of transportation.

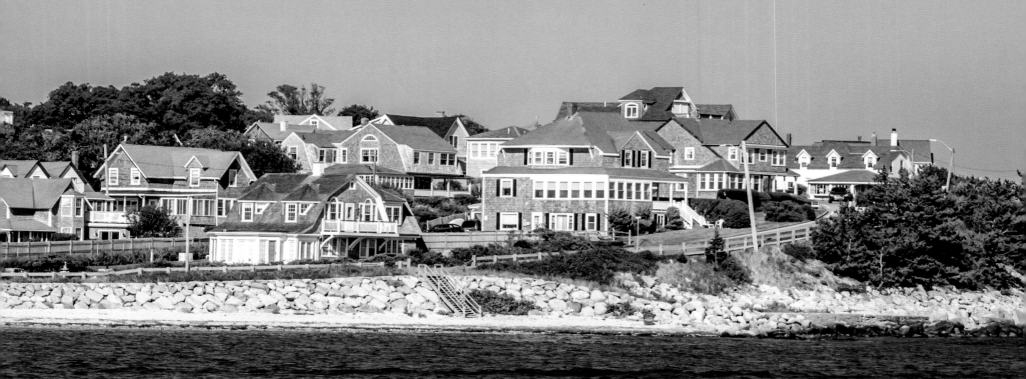

MARTHA'S VINEYARD

Arguably New England's most famous island, Martha's Vineyard is a summer destination for the affluent.

Martha's Vineyard

SIZE: 96 SQUARE MILES
LOCATION: SOUTH OF CAPE COD, MASSACHUSETTS
ACCESSIBILITY: AIRPLANE OR BOAT

Most know of Martha's Vineyard as a high-end, affluent getaway spot for the nation's rich and famous. Certainly the cost of living (and the cost of visiting, for that matter) on the island soars well above the national average. Martha's Vineyard includes Chappaquiddick Island, though at times storms have caused the two land masses to become separated. Beaches, boating, kayaking, and some of the finest restaurants and shops are among the many things to do on Martha's Vineyard. And the celebrity watching can be second to none.

BLOCK

Located on the island's eastern side, Old Harbor is right in the center of town.

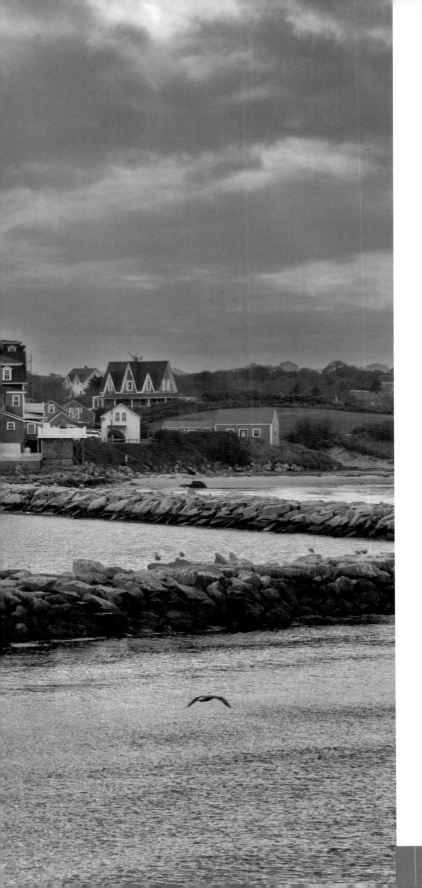

Block Island

SIZE: 7,000 ACRES
LOCATION: BLOCK ISLAND SOUND, RHODE ISLAND
ACCESSIBILITY: AIRPLANE, FERRY, OR BOAT

Its earliest inhabitants called Block Island "Manisses," which translates to "Island of the Little God." The island features about 300 ponds, although locals and regulars like to peg the number at 365—one for each day of the year. Tourists flock to enjoy Block Island's 17 miles of beaches along with biking, hiking, and fishing in the warm-weather months. During the winter, fewer than 1,000 people call Block Island home.

FIRE

The island's lighthouse is 168 feet tall. On a clear day, you can see the New York City skyline from the top.

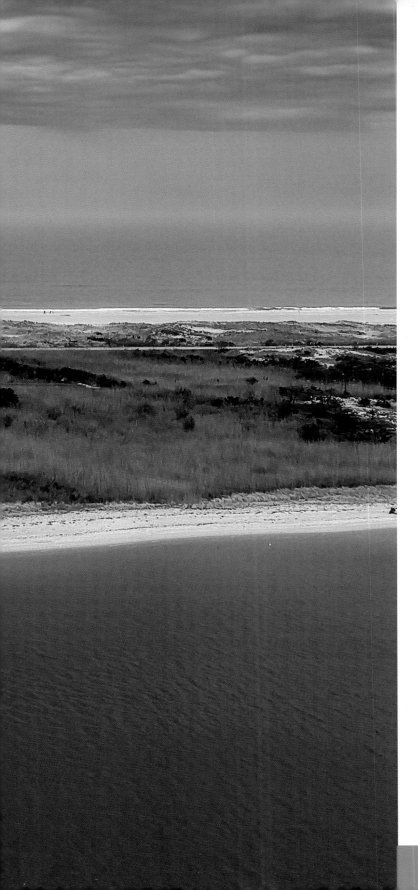

Fire Island

SIZE: 9.6 SQUARE MILES

LOCATION: SOUTH OF LONG ISLAND, NEW YORK

ACCESSIBILITY: CAR, WALKING, OR BOAT

Fire Island is the largest of the barrier islands that parallel the southern edge of Long Island. Though it stretches for more than 30 miles along the coast, not far from New York City, it still offers a tranquil setting that has made it a special place for getting away. Its beaches have official designation as a National Seashore. There's a national park featuring an eight-mile wilderness preserve in the middle, Smith Point County Park on the east side, and Robert Moses State Park on the west.

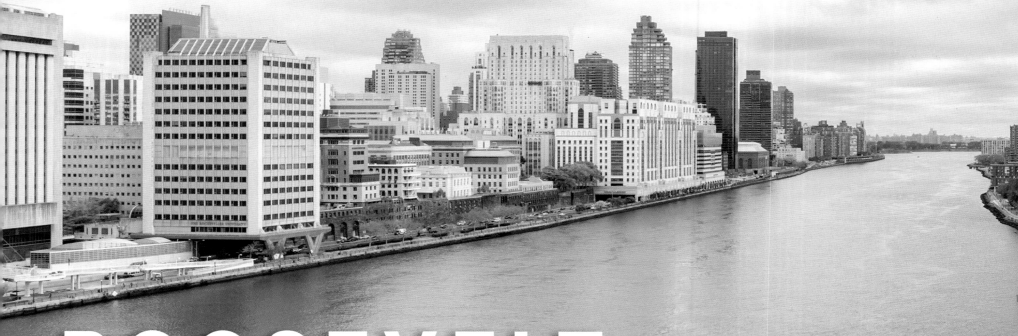

ROOSEVELT

This sliver of land (right) in the city's East River is in the middle of it all yet set off from it, like a secret oasis.

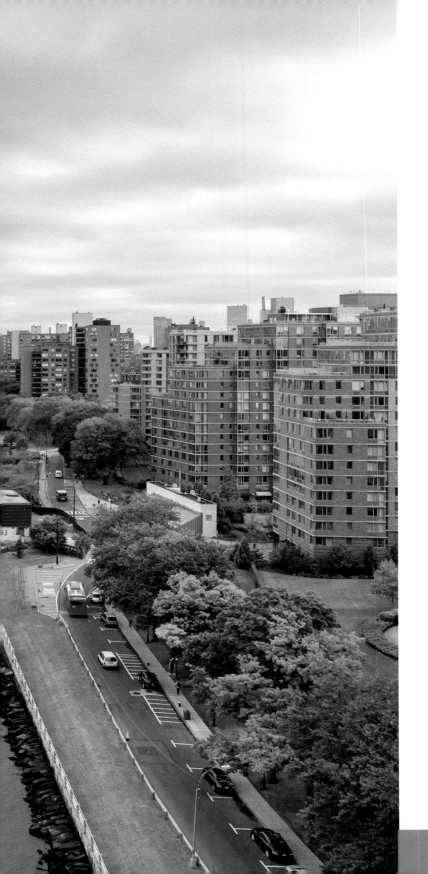

Roosevelt Island

SIZE: 2 MILES LONG

LOCATION: NEW YORK CITY

ACCESSIBILITY: SUBWAY, TRAMWAY, FERRY, WALKING, BIKING, OR DRIVING

This small, hidden gem lies between Manhattan's east side and Queens. At the southern tip of the two-mile-long strip is Four Freedoms Park, which includes a memorial honoring the island's namesake, Franklin D. Roosevelt. On the northern side is the Blackwell Island Light. It was built in 1872 by inmates of the penitentiary that used to operate on the island. From walking tours to great lunch spots to some of the most spectacular views of New York City, Roosevelt Island is well worth a day of exploration.

ELLIS

The island museum's offerings are more than enough for a day destination. The surrounding grounds offer great spots for a picnic break.

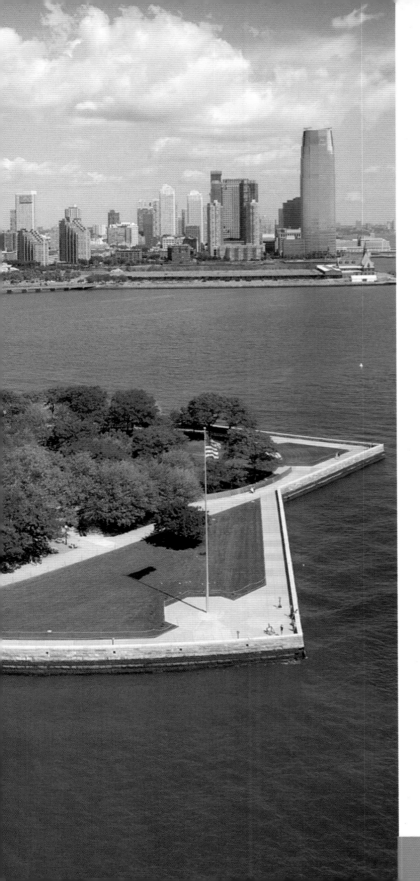

Ellis Island

SIZE: 27 ACRES

LOCATION: NEW YORK CITY

ACCESSIBILITY: FERRY

Opened in 1892, Ellis Island served as the gateway to the U.S. for more than 12 million immigrants over 60-plus years as an immigration station. It's estimated that 40 percent of all U.S. citizens can trace at least one ancestor to Ellis Island. Though much of the land on the island has been off limits to the public for decades, the Ellis Island National Museum of Immigration draws plenty of tourist traffic to the Upper New York Bay icon. Visitors can enjoy guided and audio tours.

GOVERNORS

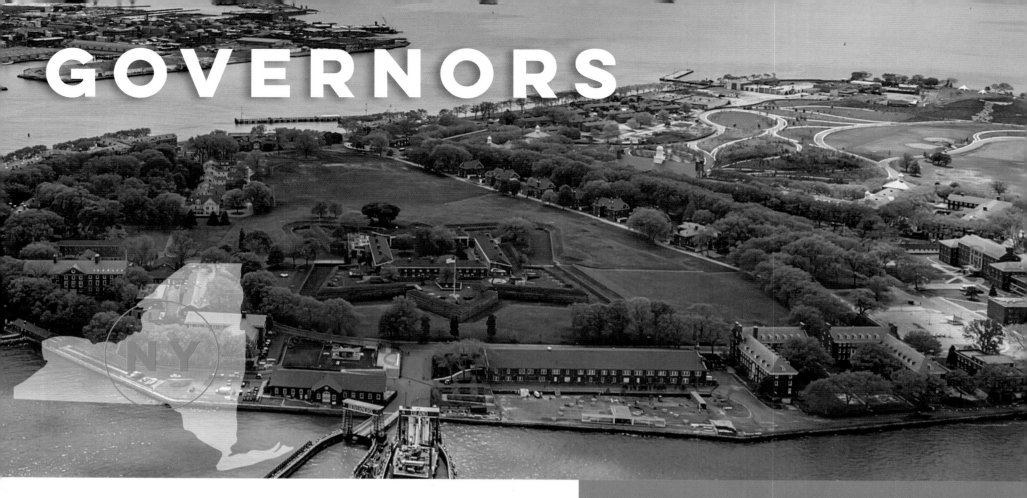

SIZE: 172 ACRES

LOCATION: MANHATTAN, NEW YORK

ACCESSIBILITY: FERRY FROM MAY THROUGH OCTOBER

Rolling green lawns and bicycle paths offer a quick getaway from the surrounding urban jungle.

Less than 1,000 yards from the southern tip of Manhattan, Governors Island offers a wonderful respite from the hustle and bustle of New York City. New Yorkers and out-of-towners alike can hop on a ferry and check out the art scene, ride a quadricycle, relax in a hammock, knock the ball around in miniature golf, or take a trip down the longest slide in New York—a 57-footer. The island also hosts several festivals, including the annual Governors Island Art Fair.

CHINCOTEAGUE

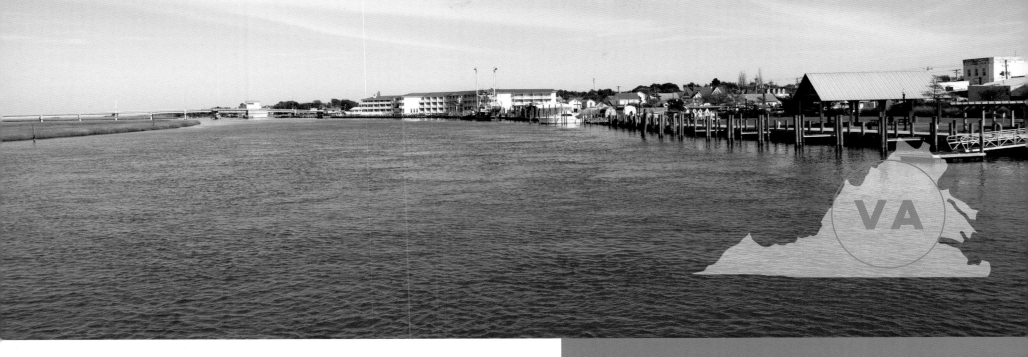

SIZE: 9 SQUARE MILES

LOCATION: EASTERN SHORE AREA, VIRGINIA

ACCESSIBILITY: CAR OR BOAT

Boat ramps and docks line the town waterfront. The area offers some of the best fishing grounds along the mid-Atlantic coast.

Chincoteague Island was once a tiny, rarely-visited fishing village on the island of the same name, but a 1961 Hollywood movie changed that forever. *Misty of Chincoteague*, based on a children's book by Marguerite Henry, introduced the world to its serene beauty. Billed as Virginia's only resort island, Chincoteague does not offer high-rise hotels or bustling boardwalks. What it does offer is plenty of unspoiled nature. In addition to biking, hiking, boating, clamming, and a waterpark for kids young and old, one of the most breathtaking attractions is checking out the famed Chincoteague Wild Ponies just up the road on Assateague Island.

SHACKLEFORD BANK

Windswept dunes and salty ponds dot this deserted barrier island. Bring your binoculars for bird- and pony-watching.

Shackleford Banks

SIZE: APPROXIMATELY 8 MILES LONG
LOCATION: CARTERET COUNTY, NORTH CAROLINA
ACCESSIBILITY: BOAT OR FERRY

Known for the feral horses that roam the land and waters with no help from man, Shackleford Banks is a stunning part of the Cape Lookout National Seashore and a popular island destination for nature and animal lovers. In addition to the horses, which one legend claims descended from mustangs that survived a Spanish shipwreck, the island offers a variety of sea life, including loggerhead turtles that nest there in the summer.

HATTERAS

Hatteras is a beach-lover's vacation destination, with miles of sand and surf.

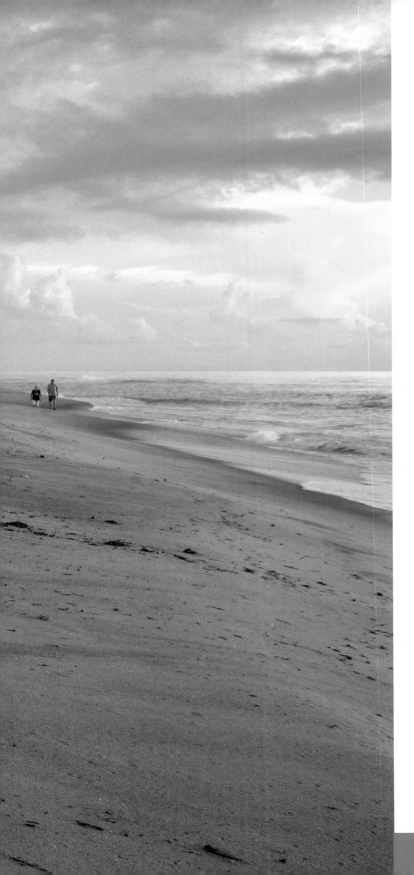

Hatteras Island

SIZE: APPROXIMATELY 50 MILES LONG

LOCATION: DARE AND HYDE COUNTIES, NORTH CAROLINA

ACCESSIBILITY: CAR, BOAT, OR FERRY

Though it's known as the blue marlin capital of the world, there is far more than sport fishing when it comes to things to do on Hatteras Island. One of the longest contiguous islands in the U.S., and part of North Carolina's Outer Banks, Hatteras truly offers something for everyone. Accommodations, restaurants, and shopping range from affordable to very high end, and the options for how to spend time on the island are virtually endless, from beachgoing to boat building, golfing, surfing, and many others. Fishing, too, of course. The island includes the largest portion of the Cape Hatteras National Seashore.

BALD HEAD

The island features not only long stretches of beach but marsh and maritime forest preserves.

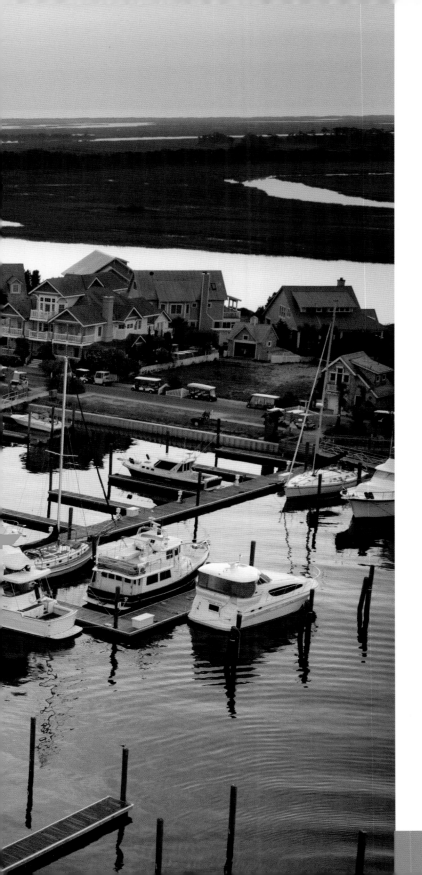

Bald Head Island

SIZE: 12,000 ACRES
LOCATION: BRUNSWICK COUNTY, NORTH CAROLINA
ACCESSIBILITY: FERRY OR BOAT

Many consider Bald Head Island the perfect getaway from the mainland. The northernmost subtropical island on the east coast, the island does not allow cars and some 10,000 of its 12,000 acres are protected as preserves. The result: peaceful splendor, along with plenty of things to do. Options abound after a 20-minute ferry ride that leaves on the hour from Deep Point Marina in Southport, N.C. Visitors can tour "Old Baldy," the oldest standing lighthouse in the state at more than 200 years old. The views from the top (it's a climb of 108 steps) are magnificent.

ROANOKE

The island is dotted with classic waterfront docks and houses. Pine trees and marshlands dominate inland.

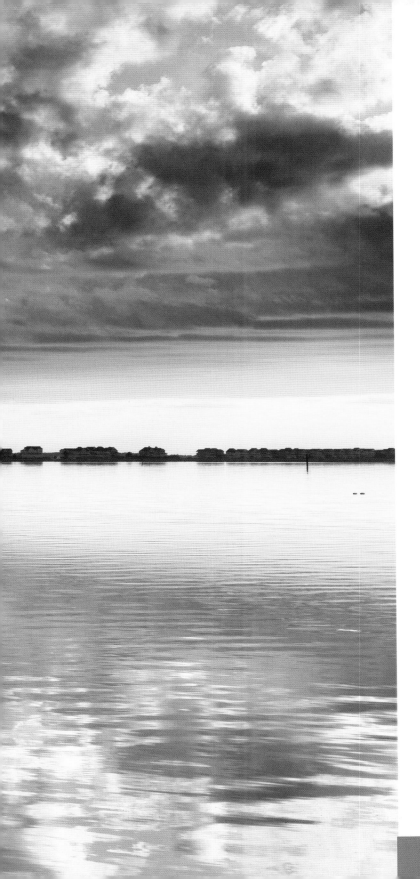

Roanoke Island

SIZE: 17 SQUARE MILES

LOCATION: DARE COUNTY, NORTH CAROLINA

ACCESSIBILITY: CAR OR BOAT

Roanoke Island is unique among the islands of North Carolina's Outer Banks for several reasons. Foremost might be its mysterious history. English settlers arrived in the 1580s but disappeared in 1590, leaving almost no trace. Historians and geologists have long searched for the "lost colony of Roanoke Island," but more legends and theories exist than concrete answers. Visitors will notice another key difference between Roanoke and the other barrier islands nearby. Because it is somewhat "shielded" from the Atlantic Ocean by the central region of the Outer Banks, its shores tend to get more serene waves that make it a beachgoer's delight.

SAPELO

The island's wooded coastline, tidal salt marshes, and maritime forests are remarkably pristine.

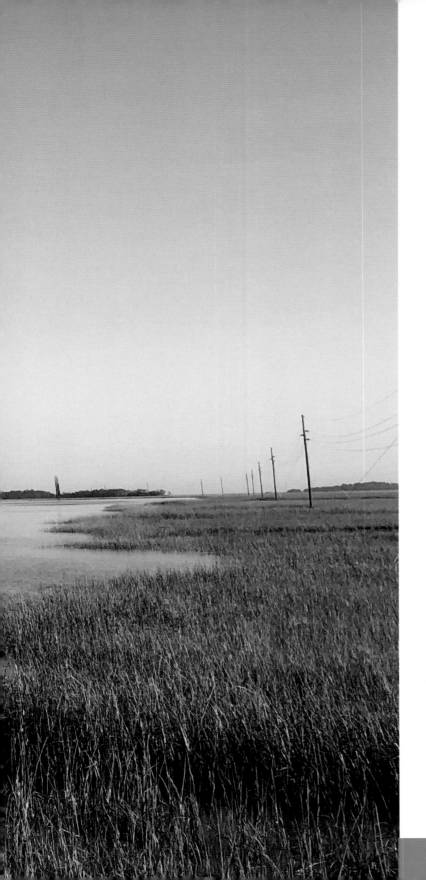

Sapelo Island

SIZE: 16,500 ACRES

LOCATION: MCINTOSH COUNTY, GEORGIA

ACCESSIBILITY: FERRY ONLY

Protected by the state of Georgia, Sapelo Island requires visitors to obtain a tourism permit to visit. Many will tell you it's well worth the effort, both for the spectacular views and the island's rich history. The island includes the community of Hog Hammock. Many of its permanent residents are Gullah-Geechees, descendants of West African slaves who worked the island's plantations in the 1700s and 1800s. Sapelo Island also features the stately R. J. Reynolds Mansion, built in 1810. The mansion provides overnight lodging for groups.

CUMBERLAND

The ruins of the immense Dungeness mansion lie at the southern end of the island. Visitors are free to explore the grounds.

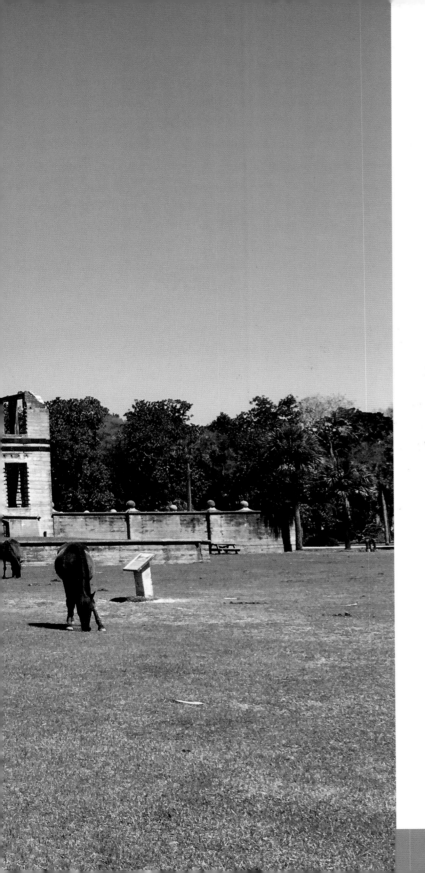

Cumberland Island

SIZE: 56 SQUARE MILES
LOCATION: CAMDEN COUNTY, GEORGIA
ACCESSIBILITY: FERRY OR BOAT

Georgia's largest and southernmost barrier island, Cumberland is both a National Park and National Seashore. Its rich history makes one of several tours offered on the island a must-do option for visitors. On the north side, one can step into the historic First African Baptist Church, where John F. Kennedy Jr. and Carolyn Bessette were married. A tour of the southern side showcases the Dungeness Estate ruins and explores the history of the Carnegie family, which maintains island roots here. There are two ways to stay on the island—the Greyfield Inn (a converted Carnegie mansion) or a National Parks Service campsite.

JEKYLL

Aptly named Driftwood Beach, this stretch of shoreline resembles a tree graveyard. The picturesque setting is popular for photography and weddings.

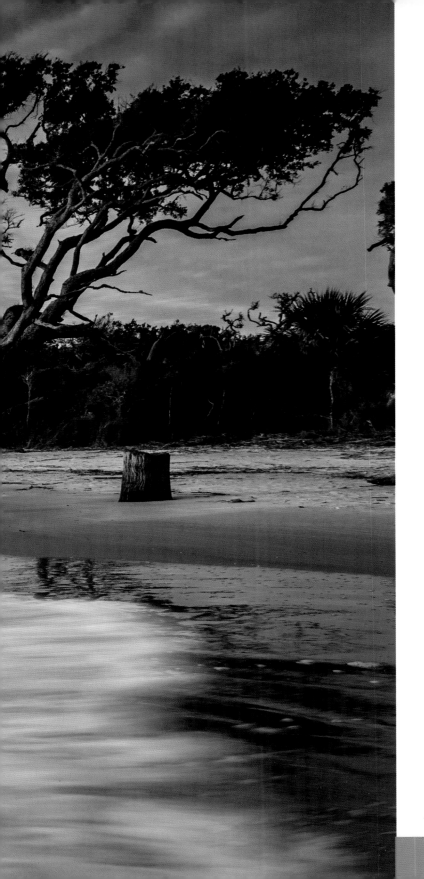

Jekyll Island

SIZE: 5,700 ACRES
LOCATION: GLYNN COUNTY, GEORGIA
ACCESSIBILITY: CAUSEWAY OR BOAT

In 1910, Senator Nelson W. Aldrich famously led a meeting of some of the nation's top financiers on Jekyll Island to plan a national monetary policy and banking system—forming the Federal Reserve as a centralized bank. That's not why visitors from all over come to the island these days, but it is one piece of the area's vast historic appeal. With all there is to see and do on Jekyll Island, it's hard to believe it's only seven miles long. Among the top attractions are the ruins of the 1742 Horton House, the lavish Jekyll Island Club Hotel (listed on the National Register of Historic Places), and the Georgia Sea Turtle Center.

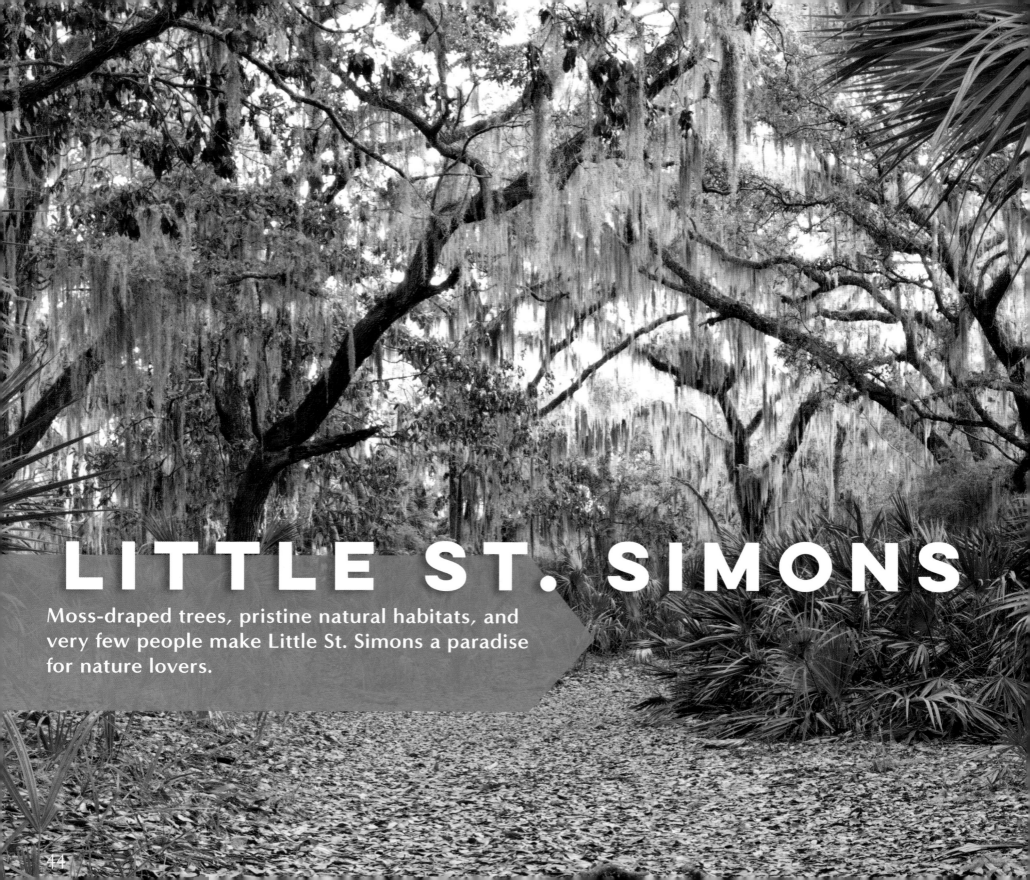

LITTLE ST. SIMONS

Moss-draped trees, pristine natural habitats, and very few people make Little St. Simons a paradise for nature lovers.

Little St. Simons Island

SIZE: 11,000 ACRES
LOCATION: HAMPTON RIVER, GEORGIA
ACCESSIBILITY: BOAT ONLY

Marshes teeming with wildlife and live oaks featuring drapes of moss greet the fortunate visitors who approach Little St. Simons Island by boat, the only way to reach its shores. Little St. Simons is the definition of a throwback. Virtually untouched for centuries and privately owned since the mid-1700s, the island is one of the least developed of Georgia's Golden Isles. Its signature is The Lodge on Little St. Simons Island. Those wishing to visit must make accommodations with The Lodge, which can put up 32 guests in an all-inclusive atmosphere.

SIESTA KEY

It's a barrier island with beaches plus all the amenities: shops, cafes, spas, and every kind of accommodation.

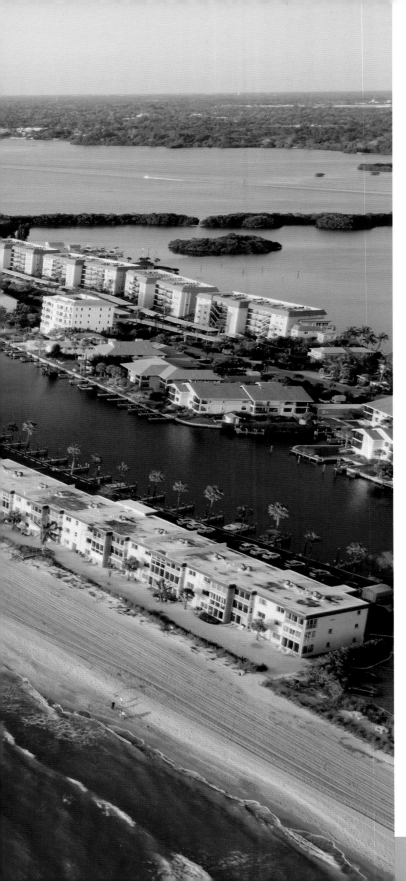

Siesta Key

SIZE: 2.4 SQUARE MILES
LOCATION: SARASOTA, FLORIDA
ACCESSIBILITY: CAR, BOAT, OR FOOT

Spanish for "nap," Siesta Key certainly offers that as an option. Even though it's definitely a laid-back vibe that visitors will find there, there's also no shortage of things to do with the eyes open. Siesta Beach, Crescent Beach, and Turtle Beach offer cool, white-powder sand that's second to none—one of the reasons the Siesta Key beaches are consistently ranked among the very best. For those who want to roam a little, groups can rent the classic Siesta Trolley for a tour of the island. There are also some great bars and restaurants, many with a tropical theme.

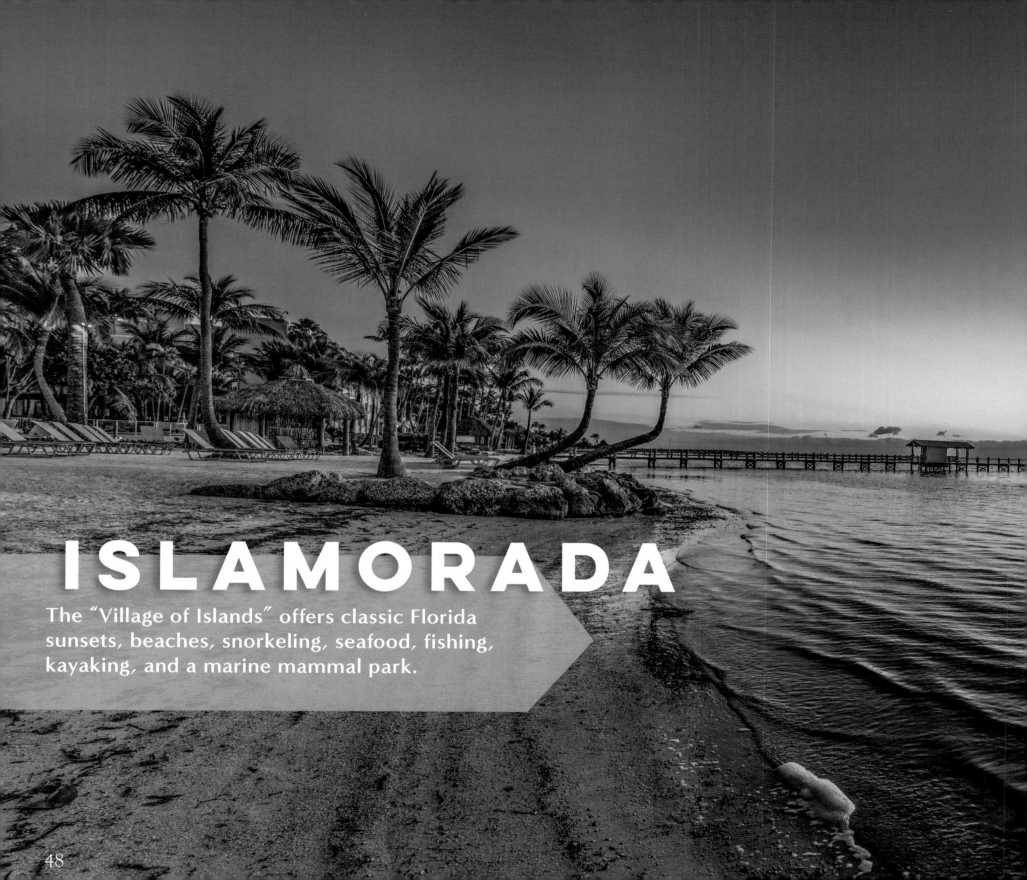

ISLAMORADA

The "Village of Islands" offers classic Florida sunsets, beaches, snorkeling, seafood, fishing, kayaking, and a marine mammal park.

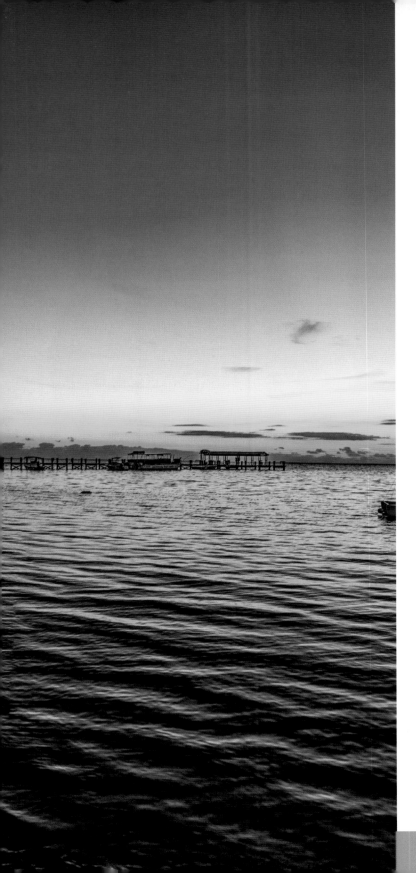

Islamorada

SIZE: 6.5 SQUARE MILES

LOCATION: FLORIDA KEYS, FLORIDA

ACCESSIBILITY: CAR, BOAT, OR FOOT

Ted Williams, perhaps baseball's best pure hitter of all time, was Islamorada's most famous resident for more than 40 years. It's no wonder "Teddy Ballgame" was also an accomplished fisherman. Sport fishing off Islamorada is legendary, so it's not surprising that amazing seafood dining options abound. The Village of Islamorada is actually comprised of six islands in the Florida Keys. There is a moving memorial to the more than 400 residents who died in a tragic 1935 hurricane.

ST. GEORGE

The island may be developed, but the beaches are still uncrowded, unspoiled, and breathtaking.

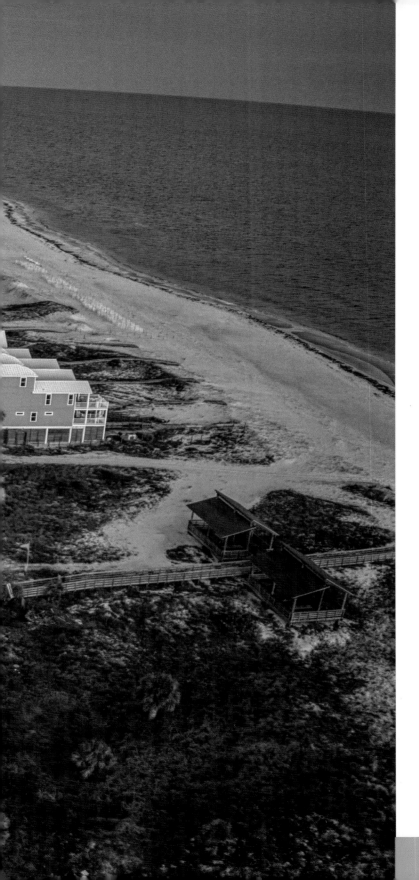

St. George Island

SIZE: 28 MILES LONG

LOCATION: FRANKLIN COUNTY, FLORIDA

ACCESSIBILITY: CAR OR BOAT

A mile-wide slice of serenity in the Gulf of Mexico, St. George Island is known for sand dunes and beaches that remain untouched by high-rise developments. The highest point is the 92-step lighthouse—Cape St. George Light—that's open for tours. Because the island is a little off the beaten path, its natural beaches are usually uncrowded. They're also pet-friendly, which is not often the case in Florida. Fishing, dining, hiking, and biking are among the other popular activities for visitors looking to get away.

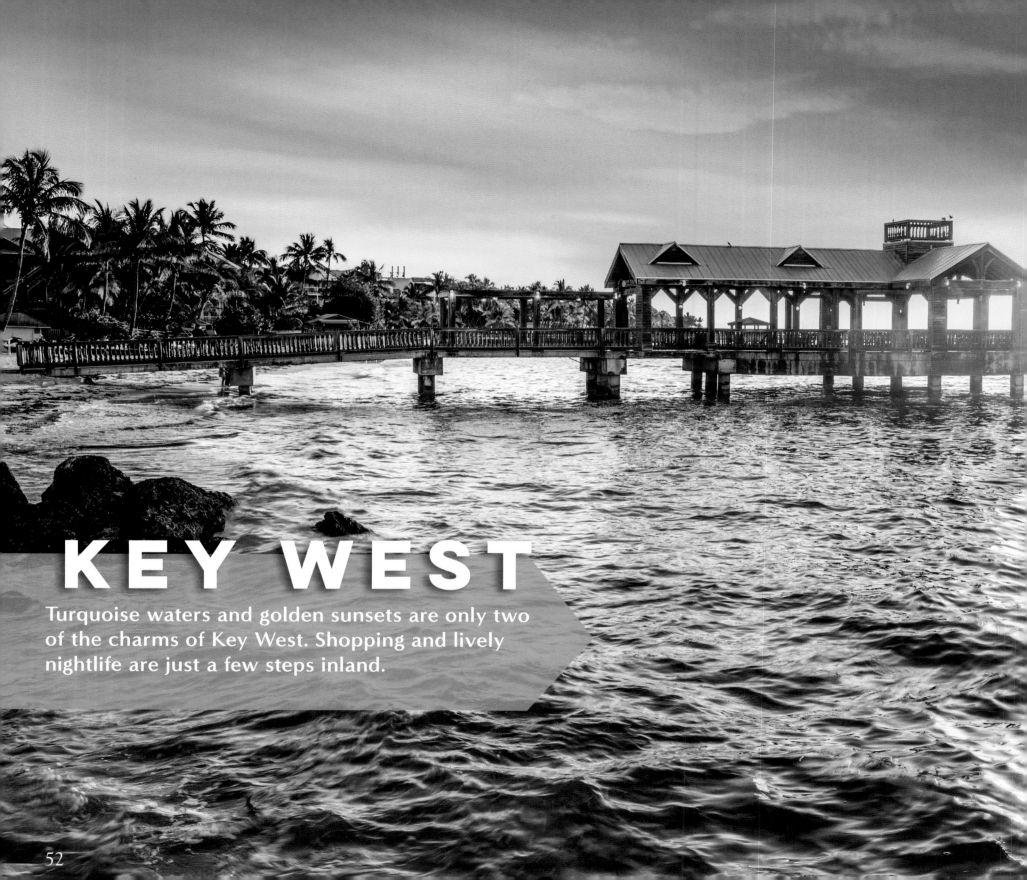

KEY WEST

Turquoise waters and golden sunsets are only two of the charms of Key West. Shopping and lively nightlife are just a few steps inland.

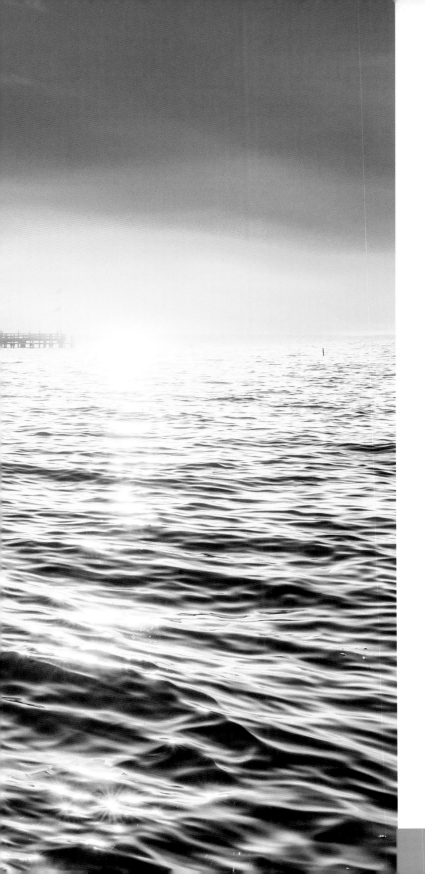

Key West

SIZE: 5.6 SQUARE MILES

LOCATION: FLORIDA KEYS, FLORIDA

ACCESSIBILITY: CAR, BOAT, FERRY, OR AIRPLANE

There is no place in the world quite like Key West, the southernmost city in the contiguous United States and a spot some might describe as perfectly removed from reality. Along Duval Street is tropical-themed nightlife that's second to none, drawing revelers from all over the world. The westernmost stop on Highway 1 along the Florida Keys is no slouch in the daylight hours, either. Two of Key West's most famous residents, Ernest Hemingway and Tennessee Williams, have historic homes that keep visiting cameras busy. There's also the Winter White House, a presidential getaway that Harry Truman made famous but has been visited by Presidents Taft, Eisenhower, Carter, and Clinton, among others.

PINE

Pine Island offers a laid-back Florida vibe amidst mangroves, palm trees, and several aquatic preserves.

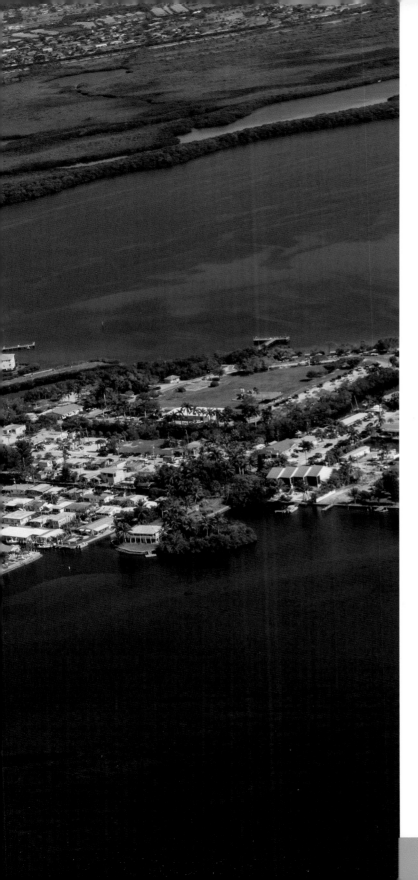

Pine Island

SIZE: 40 SQUARE MILES

LOCATION: LEE COUNTY, FLORIDA

ACCESSIBILITY: CAR OR BOAT

Surrounded by mangroves, Florida's largest island is one of the last remaining authentic fishing villages in the southwest part of the state. Getting there from Cape Coral includes a drive through the quirky town of Matlacha, which is worth a stop. Once on Pine Island, visitors will not see a single high-rise, stoplight, or even a large beach. A hammock, grove of palm trees, and Gulf breeze? Yes. The beaches on the island are the rugged coral type, and the fishing from Pine Island Sound is among the best in the state.

DRY TORTUGAS

The immense brick walls that ring Fort Jefferson were built over a number of years, beginning in 1846. This island is officially called Garden Key.

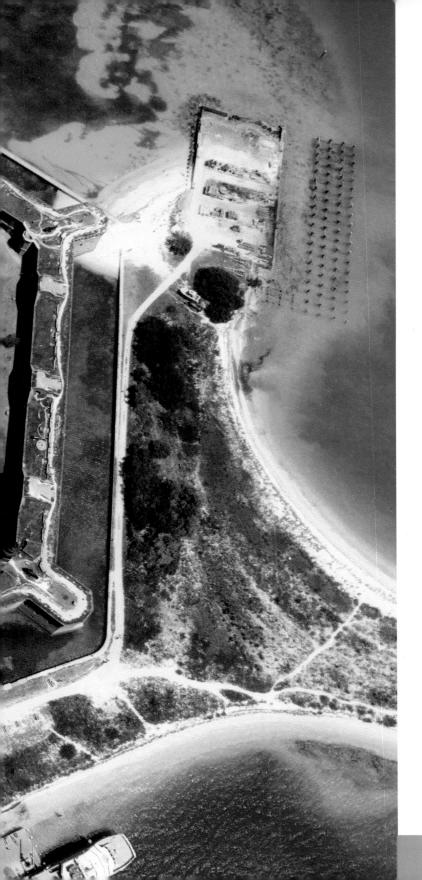

Dry Tortugas

SIZE: 143 ACRES

LOCATION: END OF FLORIDA KEYS, FLORIDA

ACCESSIBILITY: FERRY, CATAMARAN, OR SEAPLANE

The Dry Tortugas, a series of seven small islands west of the Florida Keys, were discovered by Ponce de Leon's Spanish explorers in 1513. Together with the surrounding waters, they make up the Dry Tortugas National Park. The rich history of these islands is highlighted by Fort Jefferson, which takes up almost the entire island of Garden Key. It was a Union stronghold during the Civil War and later operated as a prison. The islands also hold numerous maritime tales of shipwrecks and pirates, not to mention spectacular beaches.

GASPARILLA

The lighthouse is the oldest structure on the island and houses a popular museum.

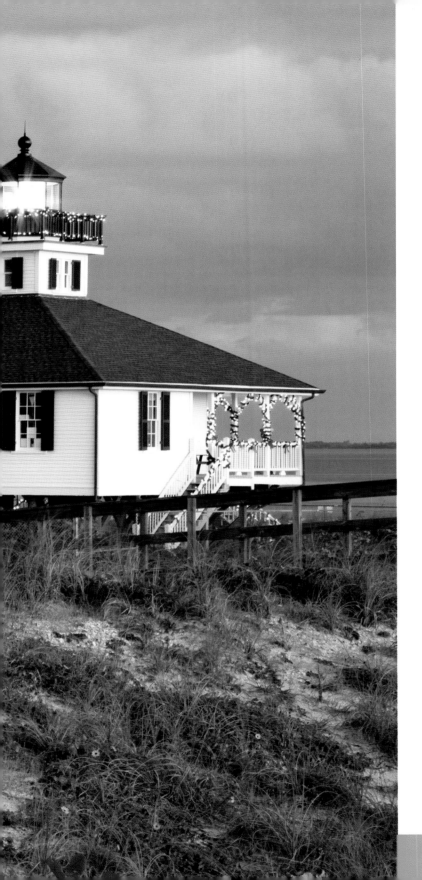

Gasparilla Island

SIZE: SEVEN MILES LONG

LOCATION: STRADDLING CHARLOTTE AND LEE COUNTIES

ACCESSIBILITY: CAR OR BOAT

Florida's "other" Boca—Boca Grande—is the jewel of Gasparilla Island, which, like Tampa's annual Gasparilla Parade, is named for the famed pirate Jose Gaspar. The pirate connection gives the island a special place in Florida folklore, but its laid-back lifestyle and serene beaches are every bit as alluring. Boca Grande (not to be confused with Boca Raton) offers several popular attractions, including the stately Gasparilla Inn, opened in 1911, and the historic Port Boca Grande Lighthouse, built in 1890. The sport fishing here is legendary.

ANNA MARIA

Miles of soft white sands and unobstructed views of both sunrises and sunsets are part of the draw of Anna Maria.

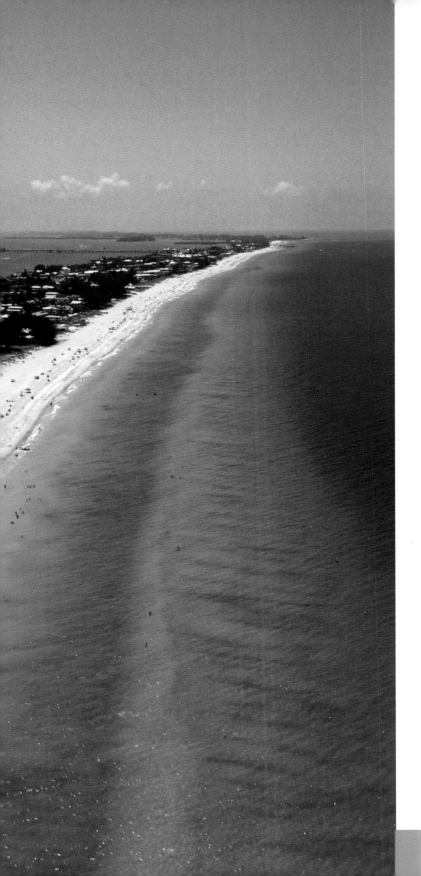

Anna Maria Island

SIZE: SEVEN MILES LONG

LOCATION: MANATEE COUNTY, FLORIDA

ACCESSIBILITY: CAR OR BOAT

First discovered by Native Americans and later by Spanish explorers, Anna Maria Island—sometimes called Anna Maria Key—is among the Florida Gulf Coast's most popular destinations for those who love powdery, white sand beaches and natural beauty. Two bridges connect Anna Maria Island from the mainland, and strict regulations on the kinds of buildings and businesses on the island help preserve the scene that greets visitors upon their arrival. There are beautiful piers, amazing fishing and, not surprisingly, some of the best seafood restaurants anywhere.

BIG TALBOT

Boneyard Beach is filled with the twisted limbs of
live oak and cedar trees.

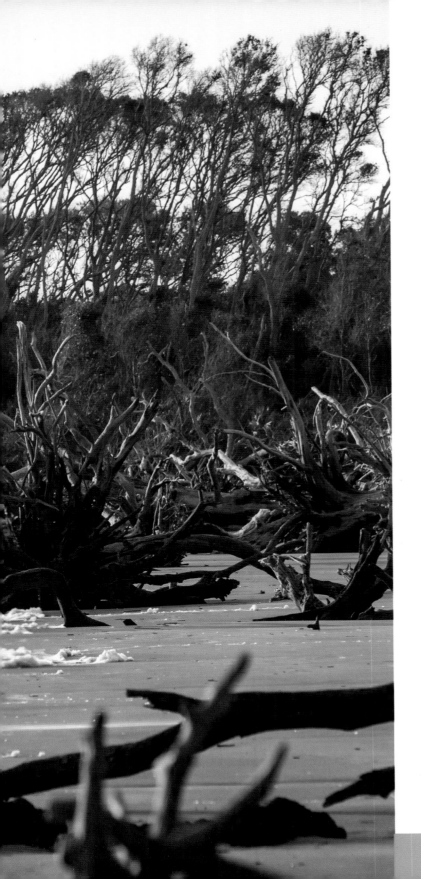

Big Talbot Island

SIZE: 3,600 ACRES

LOCATION: EAST OF JACKSONVILLE, FLORIDA

ACCESSIBILITY: CAR OR BOAT

Because Talbot is a state park and thus preserved from development, it's among the south's premier spots for bird-watching and nature photography. It's also a great place to launch a boat, take a nature hike, picnic at a pavilion overlooking the ocean, or stroll down to Boneyard Beach, famous for the skeletons of cedar and live oak trees that have been washed in the salt water. Hardpan soil deposits in the shallow water also create unique habitats where mollusks, crabs, oysters, and other sea creatures can be observed.

BAHIA HONDA

Calusa Beach, on the island's southwest end, is
partially protected from the ocean and features
calm, quiet waters.

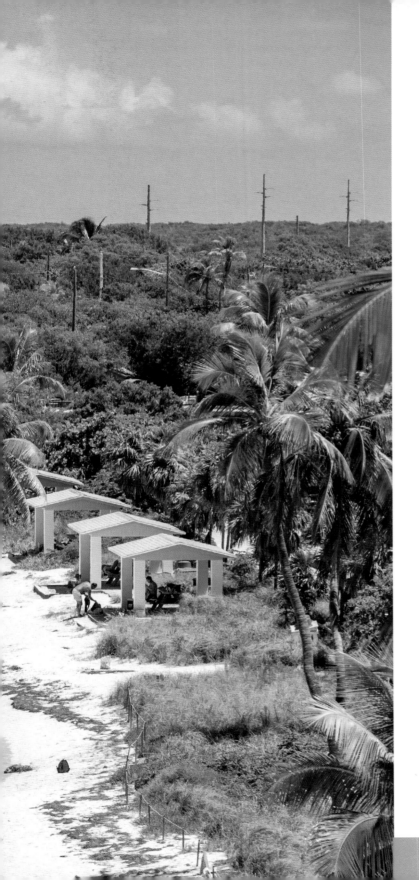

Bahia Honda Key

SIZE: 524 ACRES

LOCATION: FLORIDA KEYS, FLORIDA

ACCESSIBILITY: CAR OR BOAT

A state park with postcard-like scenery, Bahia Honda Key is a tempting stopping spot for those driving out to Key West. It's also a destination unto itself, with crystal clear water, palm-lined beaches, and spectacular sunsets. Florida railway magnate Henry Flagler built his Florida East Coast Railway to run through Bahia Honda Key to Key West, opening the former to tourists who had once never heard of it. Now it's known for its snorkeling, and also as the best place in the Keys to stargaze.

DAUPHIN

Fishing, boating, and other water sports are a major draw on the island.

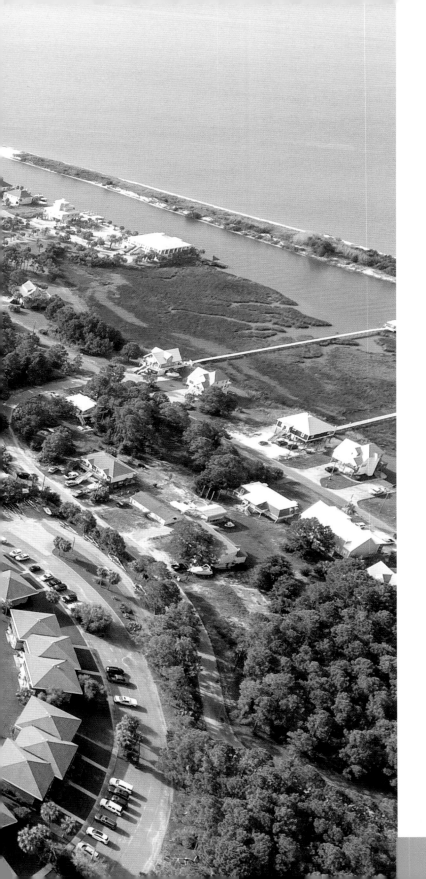

Dauphin Island

SIZE: 6.2 SQUARE MILES
LOCATION: THREE MILES SOUTH OF MOBILE BAY, ALABAMA
ACCESSIBILITY: CAR, BOAT, OR FERRY

Combine southern charm and hospitality with the pristine beauty of a barrier island in the Gulf of Mexico, and you've got Dauphin Island. Crystal clear water and powdery white sand make for some of the best beaches in the south. The island that sometimes mistakenly gets called Dolphin Island was actually named for "the dauphin," Louis XV of France. Aside from the beaches, the island is known for its Audubon Bird Society, Dauphin Island Sea Lab, and world-class Estuarium.

PADRE

While much of the island is designated as national seashore, northern sections contain residential development.

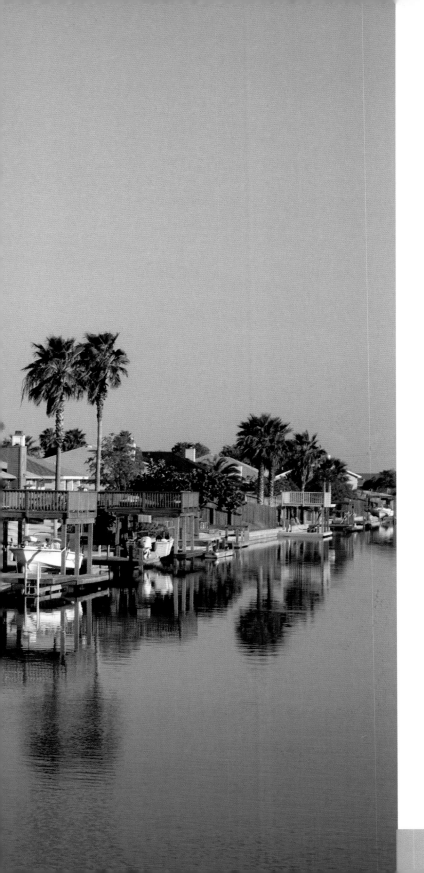

Padre Island

SIZE: 209 SQUARE MILES

LOCATION: GULF COAST OF TEXAS

ACCESSIBILITY: CAR OR BOAT

Padre Island is a unique mix of the developed and the untouched. Padre Island National Seashore, separating the Gulf of Mexico from Laguna Madre, protects 70 miles of coastline, dunes, prairies, and wind tidal flats—the longest stretch of undeveloped barrier island in the world. Both sea and land wildlife that roam the barrier lure nature lovers from all over. Also highlighting the 113-mile-long island is the action-packed side of South Padre Island. Long famed as a spring break and vacation mecca, South Padre's beaches and legendary nightlife have developed a legend all their own.

GALVESTON

Once known as the "Playground of the South," the island is still a resort destination. And it still has some of the best beaches in the state.

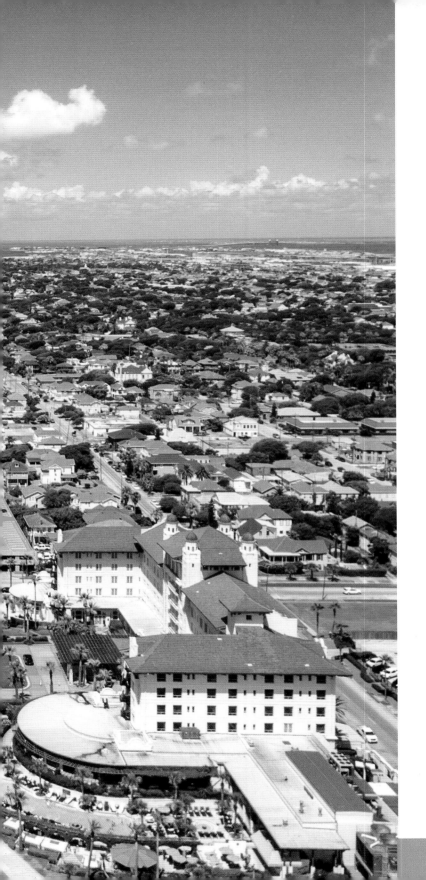

Galveston Island

SIZE: 64 SQUARE MILES

LOCATION: GALVESTON, TEXAS

ACCESSIBILITY: CAR, BOAT, OR FERRY

Though their home is contained within the city limits of Galveston, Texas, folks who live on Galveston Island identify themselves by one of two acronyms: BOI (born on the island) or IBC (island by choice). Tourists fall squarely into the latter, of course, but those of all backgrounds and distinctions come here to enjoy the renowned beaches, fishing, restaurants, and attractions. Native American and Mexican history can be seen all over the island. And for family fun, Pleasure Pier offers boardwalk and carnival fare.

MACKINAC

The quaint harbor town lies at the south end of the island. It has a yearly population of under 500 people.

Mackinac Island

SIZE: 3.75 SQUARE MILES

LOCATION: LAKE HURON, MICHIGAN

ACCESSIBILITY: BOAT, FERRY, SMALL AIRCRAFT, OR SNOWMOBILE (SOME WINTERS)

Pronounced MACK-in-aw, this island between Michigan's upper and lower peninsulas was named for an Ojibwe word meaning "turtle" due to its shape. Michiganders and those who come from much further to visit know it as a place where time stands still. Cars, chain hotels, and fast-food restaurants are nowhere to be found. What one will find is world famous Mackinac Island fudge, people of all ages exploring the island on bicycles, and historic Fort Mackinac, built in 1780 but closed in 1895 when there was no further military purpose. Native presence on the island has been established as far back as AD 900.

NORTH MANITOU

SIZE: 22 SQUARE MILES

LOCATION: NORTHERN LAKE MICHIGAN

ACCESSIBILITY: BOAT OR FERRY

Overnight visitors can camp in one of the eight designated campsites or in total forest isolation.

Shaped like an upside-down teardrop, North Manitou Island lies 12 miles off the coast of northwest Michigan. Early schooners and steam ships used the Manitou Passage as a key stopping spot between Chicago and Northern Michigan. The island has seen lumbering and agriculture come and go, but these days it is part of the Sleeping Bear Dunes National Lakeshore. 15,000 acres of forested wilderness, rolling dunes, and no permanent residents means that visitors are free to camp and wander in splendid solitude.

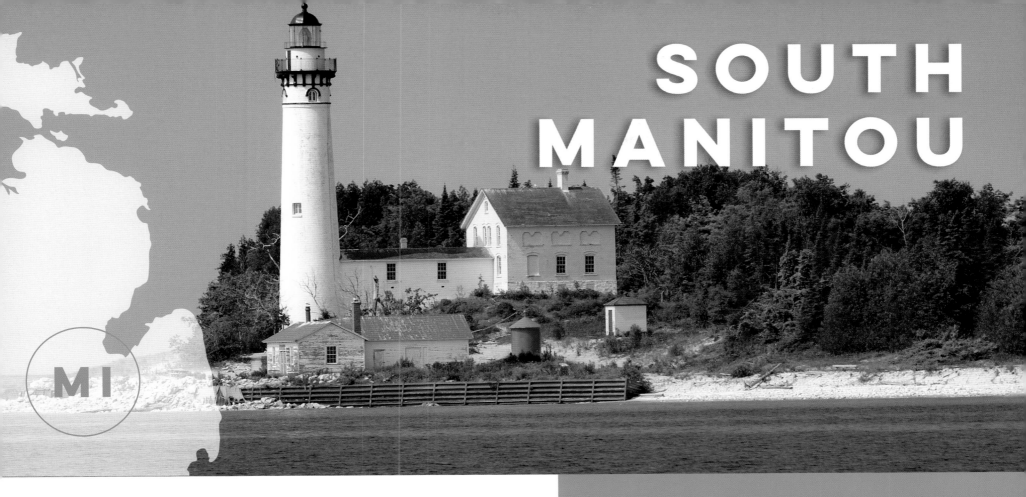

SOUTH MANITOU

MI

SIZE: 8 SQUARE MILES

LOCATION: NORTHERN LAKE MICHIGAN

ACCESSIBILITY: BOAT OR FERRY

A few buildings remain on the island, but camping is the only option for those wishing to stay overnight.

South Manitou Island is distinctive for its more-than-100-foot-high lighthouse. It was built in the 1800s to help guide ships on the rough waters of Lake Michigan. Despite its guidance, there are more than 50 shipwreck sites around the Manitou islands dating from 1835 to 1960. Several of the sites remain popular diving spots. A 3-mile hike through the forest leads to the Valley of the Giants, a stand of ancient white cedars, some of which are over 500 years old. Like its northern neighbor, South Manitou offers miles of deserted beaches. And watching the sun set from the sand bluffs of the western shore is an unforgettable experience.

NORTHERLY

Quiet paths among the wild prairie grasses and flowers offer a vivid contrast to downtown Chicago.

Northerly Island

SIZE: 91 ACRES

LOCATION: CHICAGO, ILLINOIS

ACCESSIBILITY: CAR OR FOOT

Man-made Northerly Island (technically a peninsula) was completed in 1925. Chicagoans love their Northerly Island, particularly when you can anchor your boat just offshore and enjoy a music festival or concert. The majority of its space along Chicago's lakefront is dedicated to nature, with trees scattered among the wild prairie grasses, creating a welcome getaway from the buzz of the city. Its strolling paths and numerous play areas offer amazing views of the Chicago skyline and an easy way to escape downtown crowds. It's also the location of the Adler Planetarium, and part of what's considered the city's Museum Campus.

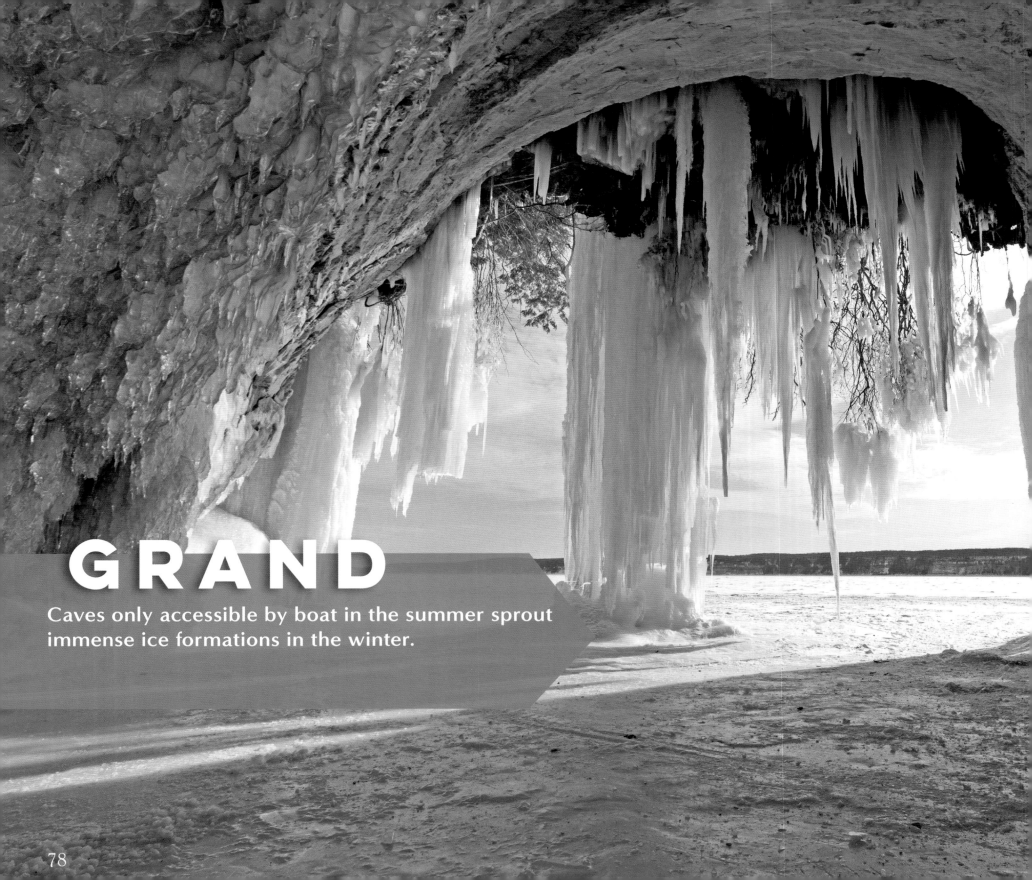

GRAND

Caves only accessible by boat in the summer sprout immense ice formations in the winter.

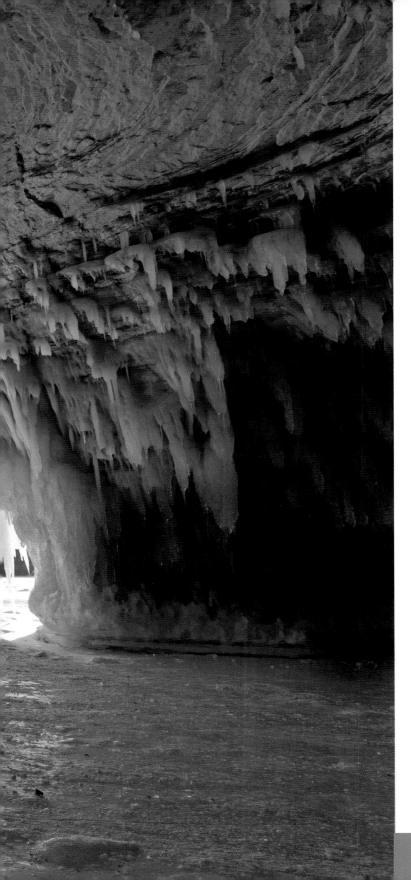

Grand Island

SIZE: 30 SQUARE MILES

LOCATION: JUST NORTH OF MUNISING, MICHIGAN

ACCESSIBILITY: BOAT OR FERRY

Part of the Hiawatha National Forest, Grand Island is a breathtaking example of the beauty of the North Woods. Camping at one of its 17 designated sites allows visitors some of the most spectacular stargazing anywhere, not to mention 300-foot-high sandstone cliffs, a 23-mile trail around the island's perimeter and stunning views of Pictured Rocks National Lakeshore. The first settlers arrived during the fur trade in the early 1800s, but archaeological evidence of life on the island dates back to pre-1000 BC.

ISLE ROYALE

No towns, roads, or cabins break up the heavily-forested, rugged shoreline. Exploration is possible only on foot or by boat.

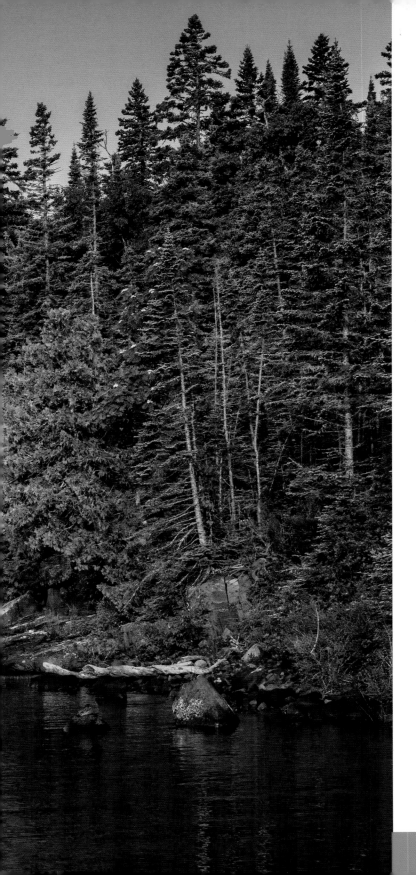

MI

Isle Royale

SIZE: 206 SQUARE MILES

LOCATION: NORTHWEST LAKE SUPERIOR, MICHIGAN

ACCESSIBILITY: BOAT, FERRY, OR SEAPLANE

Though statistics don't do this island justice, they do tell an interesting story. Isle Royale is one of the least visited national parks in the United States. However, it is one of the most *revisited*. It certainly speaks to the impact of the experience upon those who set foot on this Lake Superior gem. Raw, remote, wild, and cold for much of the year (inaccessible in the winter), Isle Royale is not for everyone. Yet its rocky majesty is unmistakable. The island was formed by ancient lava flows and sculpted by glaciers for ages. Intrepid explorers could walk for days through a boreal forest of birch, spruce, fir, and aspen. But visitors should be on the lookout: moose and wolves roam wild here.

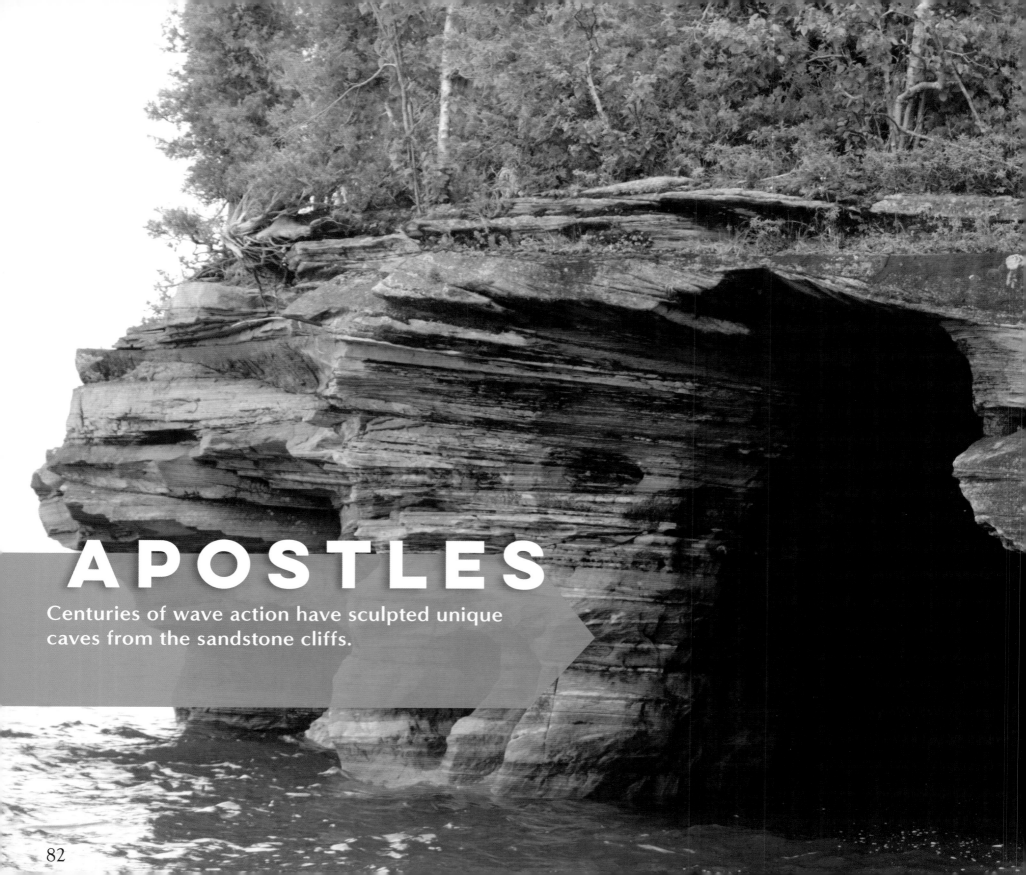

APOSTLES

Centuries of wave action have sculpted unique caves from the sandstone cliffs.

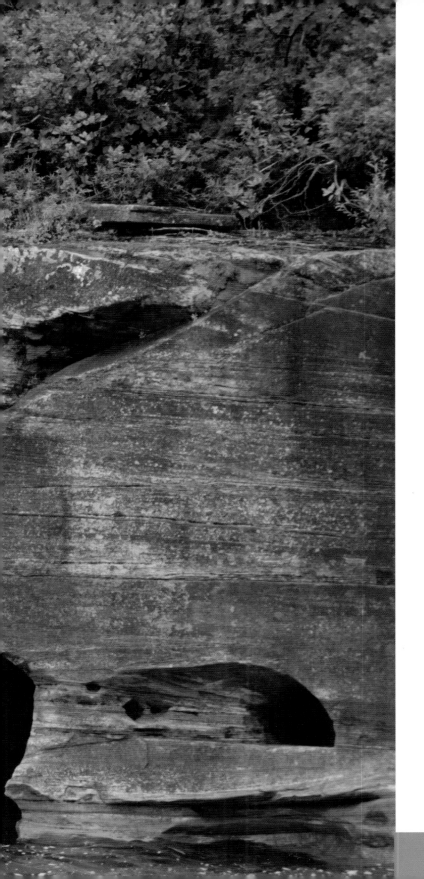

Apostle Islands

SIZE: 55,000 ACRES TOTAL (22 ISLANDS)
LOCATION: OFF BAYFIELD PENINSULA, WISCONSIN
ACCESSIBILITY: BOAT, FERRY, OR KAYAK

A beautiful collection of 22 islands, all but one—Madeline Island—fall within the Apostle Islands National Lakeshore. Nature has done the majority of the artistic work here, and it's a wonder to behold. There are intricate sea caves unlike anything else in the U.S., golden natural rock formations, windswept beaches and Lake Superior waters teeming with life. Land wildlife abounds, too, including one of the largest concentrations of black bears in North America. Eight historic lighthouses also grace the islands. The islands range in size from 15,000-plus acres (Madeline) to 165 acres (North Twin).

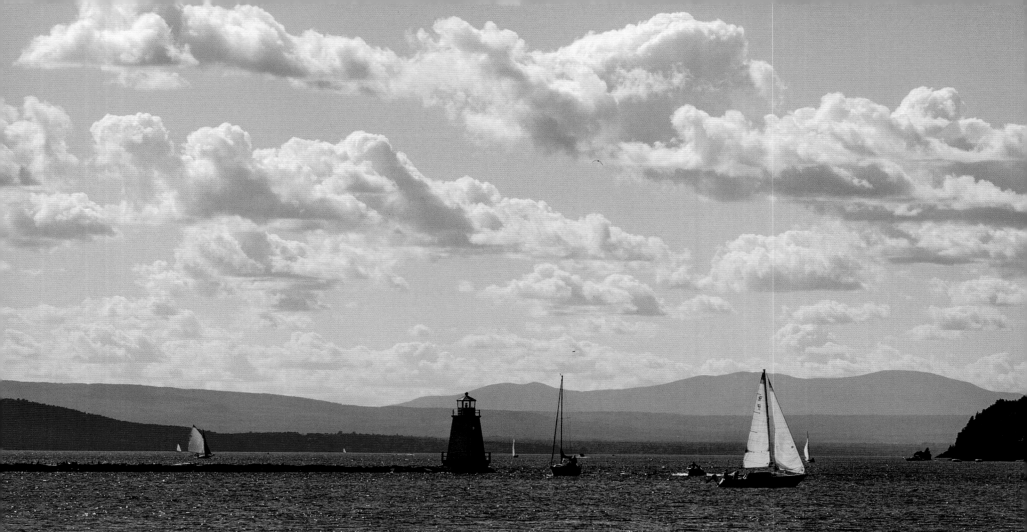

LAKE CHAMPLAIN

Sailboats drift on a perfect summer day. There are over 70 islands on Lake Champlain.

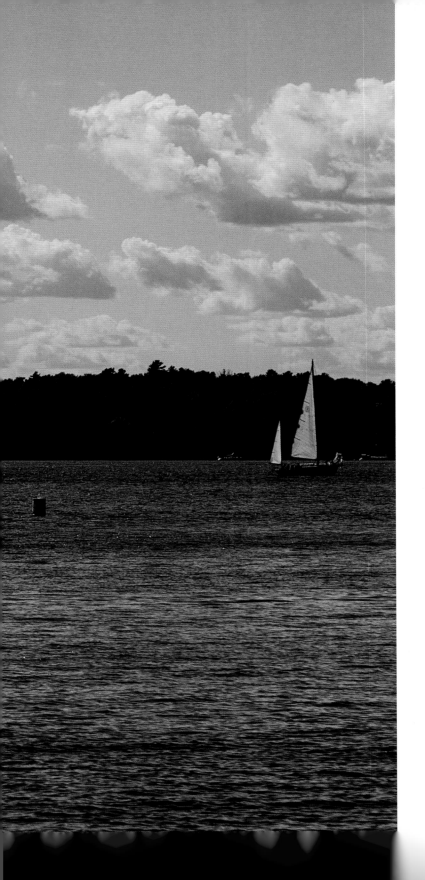

Islands of Lake Champlain

SIZE: VARIED

LOCATION: NORTHERN LAKE CHAMPLAIN, VERMONT

ACCESSIBILITY: BRIDGES, BOAT, OR FERRY

Vermont islands like Isle La Motte, South and North Hero, and the town of Grand Isle on the northern end of massive Lake Champlain have held a magnetic pull for city-dwellers for as long as American cities have existed. In addition to their allure as beautiful places to get away, hike, fish, or immerse oneself in nature's beauty, each island has a story. There's also one big tale they all share—that of Champ, the mythical (we think) sea monster who's been "spotted" several times from these islands' shores.

GOAT

The Goat Island Road bridge crosses the churning waters of the Niagara River. From the bridge, the Falls are about 1,100 feet away.

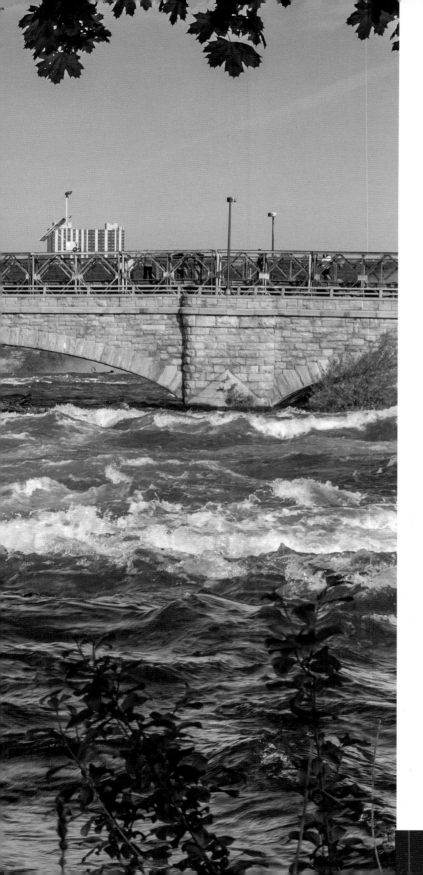

Goat Island

SIZE: 70 ACRES

LOCATION: NIAGARA FALLS, NEW YORK

ACCESSIBILITY: CAR, TRACKLESS TRAIN, AND FOOT VIA BRIDGES

Nestled beautifully between Bridal Veil Falls on the American side and Horseshoe Falls on the Canadian side, Goat Island offers some of the most spectacular, close-up views of Niagara Falls. Early pioneer and miller John Stedman once kept a herd of goats on the island, giving it its name. The brutal winter of 1780 wiped out his goats, unfortunately, but the island has been preserved as a "must" stop for anyone visiting the falls. There are two bridges that carry foot traffic and cars across from the mainland (on the U.S. side only). The island and its botanical beauty are a stunning part of the oldest state park in the U.S.

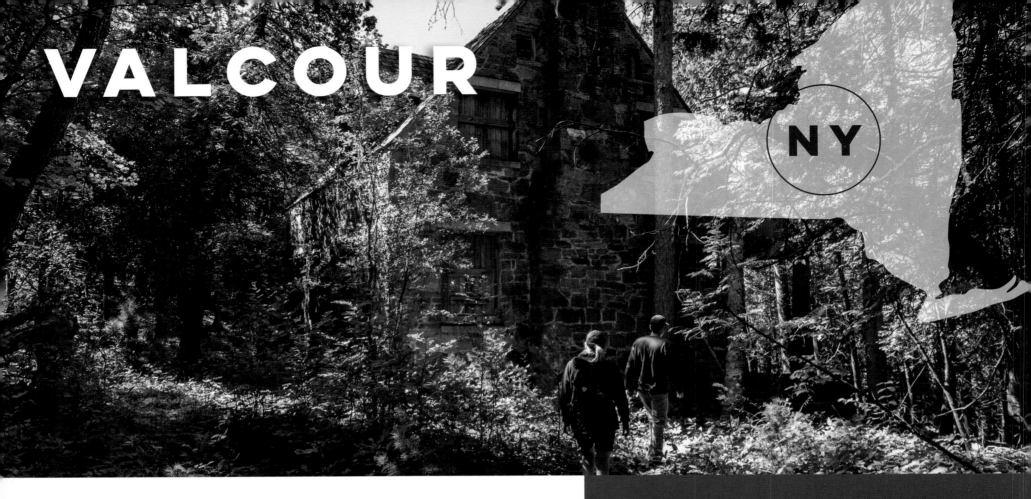

VALCOUR

NY

SIZE: 2 SQUARE MILES
LOCATION: CLINTON COUNTY, NEW YORK
ACCESSIBILITY: BOAT OR FERRY

Encroaching forest surrounds an abandoned house. The entire island has been designated a Primitive Area within the Adirondack Park.

Shared between the towns of Peru and Plattsburgh, Valcour Island has been preserved in its entirety by New York State. Sure, it's beautiful and offers outdoor enthusiasts a variety of things to see and do, including the Bluff Point Lighthouse. However, the history of this island is what gives it special appeal. The island played a key role in several Revolutionary War battles. Benedict Arnold decided to anchor his fleet in the channel between the island and New York state, waiting for the British before the pivotal Battle of Valcour in 1776.

NICOLLET

SIZE: .075 SQUARE MILES

LOCATION: MINNEAPOLIS, MINNESOTA

ACCESSIBILITY: CAR, BICYCLE, OR FOOT

Fewer than 200 people live on this quirky city island in the middle of the Mississippi River. Views of the city skyline can be seen through the trees.

Located just north of St. Anthony Falls in Minneapolis, Nicollet Island is named for explorer and scientist Joseph Nicollet. Nicollet became captivated by St. Anthony Falls in 1838, but he never could have envisioned the growth the Twin Cities would undergo in the almost two centuries since. That growth all around the site has made Nicollet Island a true respite for those wanting to enjoy a bike ride, stroll, or jog just a stone's throw from downtown Minneapolis. The jewel of the island is the Nicollet Island Inn, which has been dubbed the best spot in Minneapolis both to stay and to dine.

WILD HORSE

The rolling hills of the island are dotted with grassland and forest.

Wild Horse Island

SIZE: 2,100 ACRES

LOCATION: FLATHEAD LAKE, MONTANA

ACCESSIBILITY: BOAT

Wild Horse is the largest island in a freshwater lake west of Minnesota. The only access to the Flathead Lake wonder is by boat, and many will say it's well worth the trip. A small handful of wild horses (hence the name), along with bighorn sheep, mule deer, songbirds, waterfowl, bald eagles, and falcons are among the wildlife enjoying the island. Legend holds that the Kootenai tribe used the island to protect their horses from raids by rivals. The fauna, flora, and scenic shoreline continue to entice hikers, boaters, and swimmers.

ANTELOPE

The Antelope Island bison herd is one of the oldest publicly-owned herds in the country. The number of the herd fluctuates but may top 700 in some years.

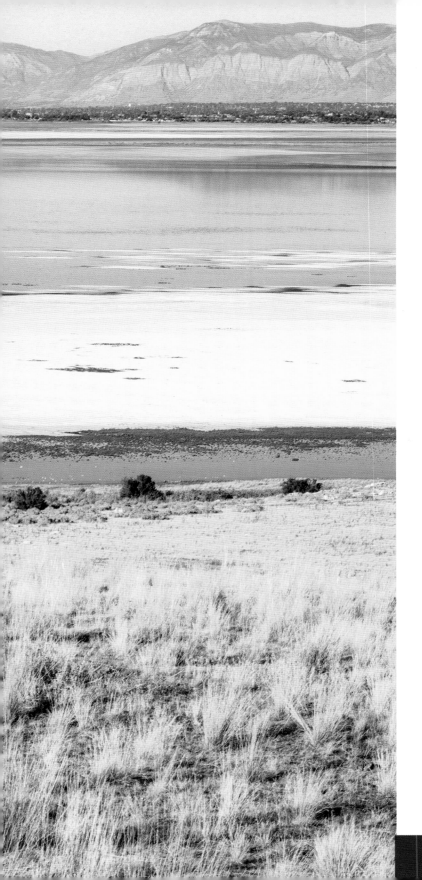

Antelope Island

SIZE: 42 SQUARE MILES

LOCATION: GREAT SALT LAKE, UTAH

ACCESSIBILITY: CAR OR BOAT

Frontiersmen John C. Fremont and Kit Carson were exploring the Great Salt Lake in the mid-1800s when they were told by natives that this island held loads of fresh water and antelope for hunting. They spotted an antelope just as they arrived on horseback through the water, and the island was forever named. Though antelope had to be reintroduced to the island in 1993, the wildlife here is truly a draw. Hundreds of American bison roam its lands, along with coyote, bobcats, deer, and countless birds and waterfowl.

KALISPELL

Tranquil views and peaceful waters entice fishermen, hikers, and nature lovers.

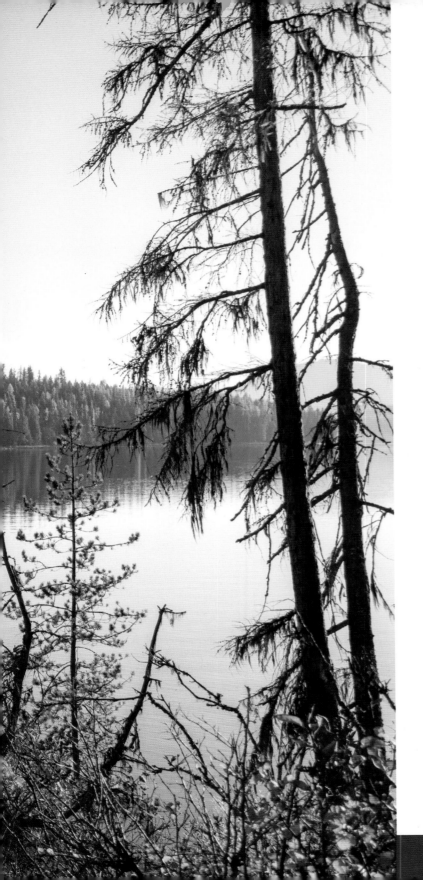

Kalispell Island

SIZE: 264 ACRES
LOCATION: PRIEST LAKE, IDAHO
ACCESSIBILITY: BOAT ONLY

Shaped like a tooth, Kalispell is the largest of the seven islands on beautiful Priest Lake. It's also the most visited, thanks largely to its reputation as one of the best places to camp. There are more than 50 campsites, open on a first-come, first-served basis, spread among three separate areas on the island. Day trips are also popular. A trail circling the island offers fun hiking and fabulous views of the facing Selkirk Mountains. The island is also a great spot for fishing, nature photography, and bird-watching.

WIZARD

Wizard rises 763 feet above the lake. At the island's summit is a 100-foot-deep volcanic crater nicknamed "Witches Cauldron."

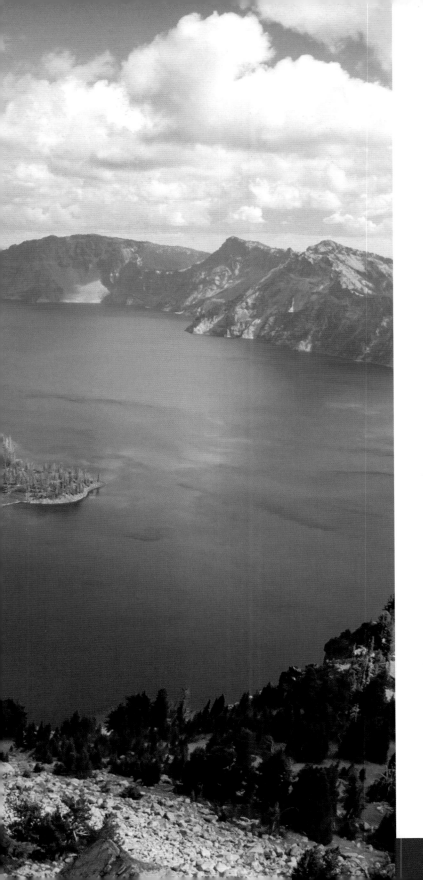

Wizard Island

SIZE: 316 ACRES

LOCATION: CRATER LAKE, OREGON

ACCESSIBILITY: VIA TOUR BOAT ONLY, SUMMER MONTHS

Part of Crater Lake National Park, Wizard Island is actually a cinder cone nestled in the caldera of a sleeping volcano. Crater is the deepest lake in America, and its waters are some of the most pristine. There are no houses or roads on Wizard. At the island's dock there is a steep 2-mile loop trail that ascends and circles the summit. Since a hike averages no more than an hour and the boat is sometimes delayed, bring your fishing pole and swimsuit—both fishing and swimming are permitted.

SAUVIE

The Sauvie Island Bridge is the only way onto the island. Sauvie Island is larger than Manhattan but has less than 1,500 residents.

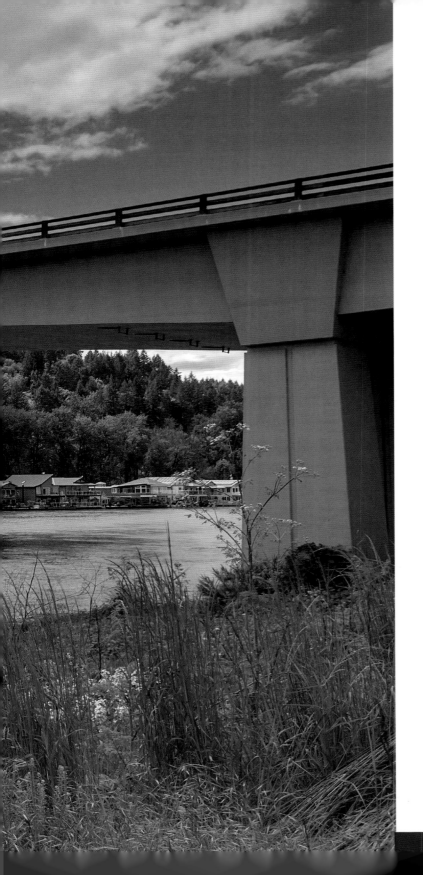

Sauvie Island

SIZE: 26,000 ACRES

LOCATION: COLUMBIA RIVER, OREGON

ACCESSIBILITY: CAR OR BOAT

Sauvie is the largest island on the Columbia River and one of the largest river islands in the U.S. The ancestral home of the region's Multnomah people, it was settled in the 1800s after the Lewis and Clark expedition landed there. Home to approximately 1,000 year-round, the island consists mostly of farmland. Goose hunting, pumpkin patches, bicycling, hiking, and kayaking are among the many reasons people cross the Sauvie Island Bridge to spend a day there. There are also a few historic sites to see—the Classic Revival-style Bybee-Howell House, former fur-trading outpost Fort William, and the tiny Warrior Rock Lighthouse.

PAOHA

Tufa towers (cement-like mineral spires) dot the waters around Paoha.

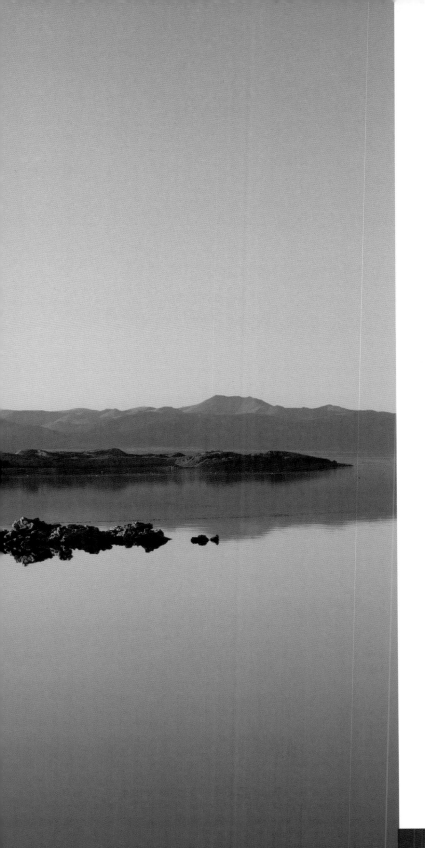

Paoha Island

SIZE: 3.5 SQUARE MILES
LOCATION: MONO LAKE, CALIFORNIA
ACCESSIBILITY: BOAT, CANOE, OR KAYAK

This fascinating volcanic island in the waters of Lake Mono did not exist just 350 years ago. It was then that volcanic eruptions on the lakebed caused Paoha to rise nearly 300 feet above lake level (at more than 6,600 feet above sea level). It got its name from a Paiute word referencing spirits that some believed lived in the island's hot springs. Volcanic ash is scattered around the island and, at its highest points on the east side, volcanic domes climb some 200 feet. Varying levels of activity over the last three centuries have given Paoha ruins of an old dwelling and picnic tables on unique beachfronts.

SANTA CATALINA

Avalon Bay, with its beach, boats, and busy harbor, is the center of focus, with streams of visitors arriving every day.

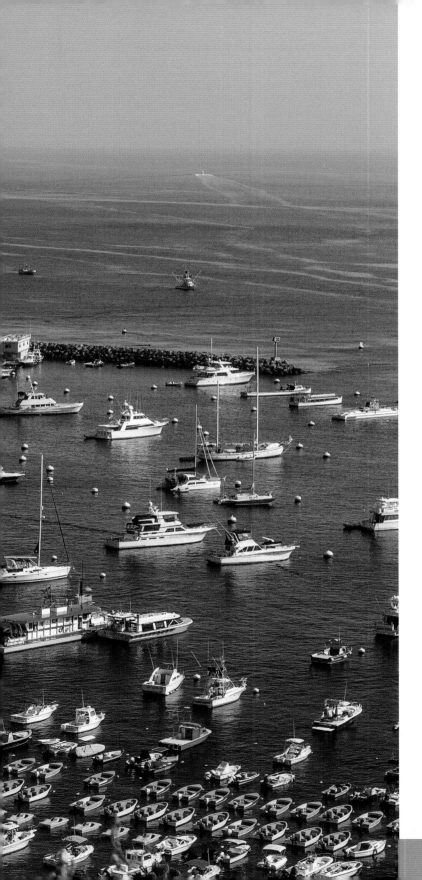

Santa Catalina Island

SIZE: 75 SQUARE MILES

LOCATION: SOUTHERN CALIFORNIA

ACCESSIBILITY: BOAT, PLANE, OR HELICOPTER

The former home of Marilyn Monroe and one-time spring training base of the Chicago Cubs, Catalina is well known as a destination for Hollywood's rich and famous. However, there's more to this island than its posh parties, wine estate, and non-gambling-style Catalina Casino. Its largest city, Avalon, is nestled into the bluffs like a picturesque Mediterranean town. More than 80 percent of the island is under the control of the Catalina Island Conservatory, preserving much of the land as wilderness. Approximately one million people visit Catalina annually, enticed by warm waters, spectacular sunsets, and perhaps its unique history.

CHANNELS

Rocky peaks, cliffs, and ridges provide rugged trails and epic views for intrepid hikers.

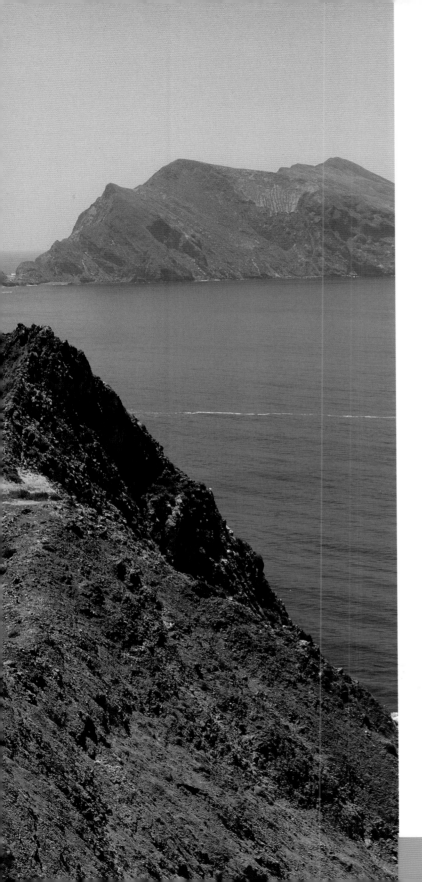

Channel Islands

SIZE: 350 SQUARE MILES

LOCATION: SANTA BARBARA CHANNEL, CALIFORNIA

ACCESSIBILITY: BOAT OR AIRPLANE

The five islands that make up the Channels are not far from the California coast, but a world apart in many ways. Anacapa, Santa Cruz, Santa Rosa, San Miguel, and Santa Barbara islands are home to more than 2,000 plant and animal species, more than 140 of which cannot be observed anywhere else in the world. The islands earned national park designation in 1980 in an effort to preserve the natural wonders nature has created over the millennia. Human presence can be traced back some 13,000 years here.

TREASURE

An eccentric little island neighborhood in the middle of the Bay with fantastic views of the city skyline—what's not to love?

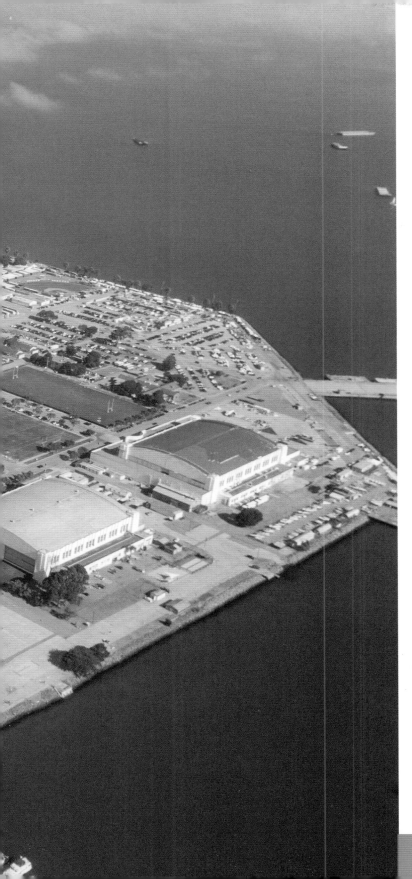

Treasure Island

SIZE: 0.9 SQUARE MILES

LOCATION: SAN FRANCISCO, CALIFORNIA

ACCESSIBILITY: BUS, CAR, BOAT, OR BICYCLE

San Francisco is made up of several unique and distinct neighborhoods, and Treasure Island might just be the strangest. There are avenues on the man-made island named B, C, D, E, F, G, H, I, M, and N, but not A, J, K, or L. There's a forbidden area in the middle, with no explanation as to why. Legends abound. The island was built, basically from rubble, to host the 1939 Golden Gate Exhibition, so its history—including history as a Naval base—is brief but interesting. A little more than 2,000 call Treasure Island home.

ALCATRAZ

Treacherous currents, cold and choppy waters, and the occasional circling shark made a swimming escape nearly impossible.

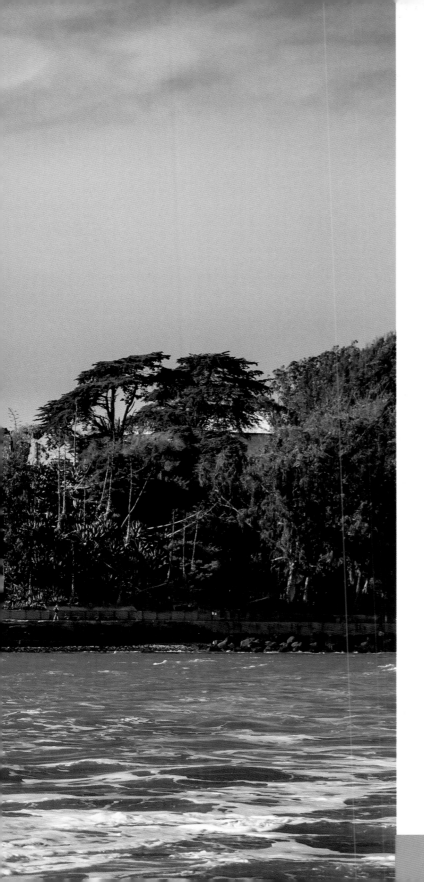

Alcatraz Island

SIZE: 22 ACRES

LOCATION: SAN FRANCISCO, CALIFORNIA

ACCESSIBILITY: ALCATRAZ ISLAND FERRY ONLY

"The Rock" is one of San Francisco's most popular and most photographed attractions. Of course, people come from far and wide to tour the federal prison that once held the likes of Al Capone and Robert "Birdman" Stroud. There's a self-guided audio tour that covers some of the daring (and one possibly successful) escape attempts, and a fascinating guided tour included with each ferry ticket. The prison was in operation just 30 years, but Alcatraz's rich history covers much more—years as a military outpost and military prison, along with an 18-month Native American occupation in its post-prison days.

ANGEL

Trees dot the island, but fantastic views of the surrounding bay can be found at the top of most hills. The highest point (center) is Mount Livermore.

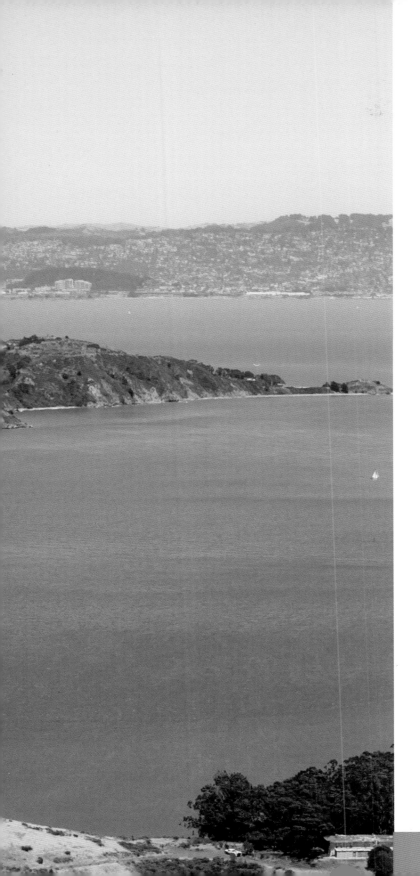

Angel Island

SIZE: 1.2 SQUARE MILES
LOCATION: SAN FRANCISCO, CALIFORNIA
ACCESSIBILITY: BOAT OR FERRY

A short ferry ride from Tiburon or San Francisco, Angel Island is truly a getaway from city living. Its 360-degree views of the San Francisco skyline, Golden Gate and Bay bridges, Mount Tamalpais, and San Francisco Bay make it a must-visit for photography buffs. It's also popular among hikers, campers, and those who have only heard about but long to taste the famed Way Down South barbecue pork sandwich at Angel Island Café. The island has a fascinating history, having served as a U.S. Public Health Service quarantine station (Bubonic plague) and a detention facility for the U.S. Immigration Service (1910–1940).

WHIDBEY

The island is known for its laid-back atmosphere. Visitors have the option of luxurious bed and breakfasts or primitive campgrounds.

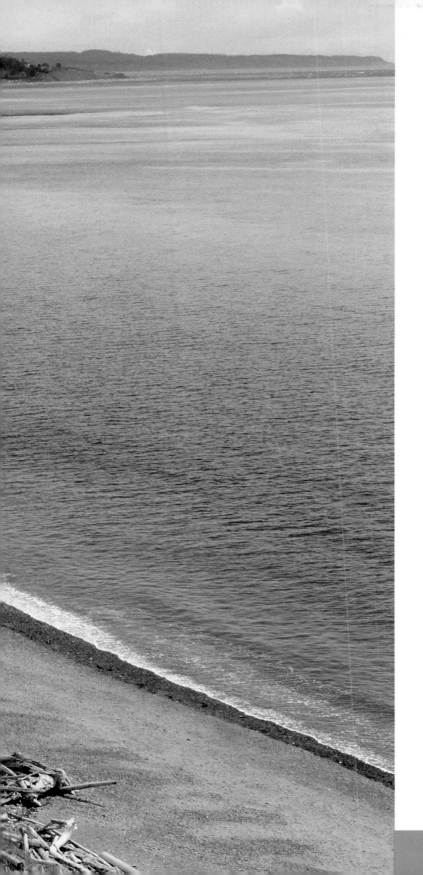

Whidbey Island

SIZE: 168 SQUARE MILES

LOCATION: ISLAND COUNTY, WASHINGTON

ACCESSIBILITY: CAR, BOAT, FERRY, OR AIRPLANE

One of the longest islands in the continental U.S. at 37 miles, Whidbey stays hopping with festivals celebrating music, kites, mussels, running, dogs, and even fictional murder mysteries. It contains Ebey's Landing National Historical Reserve, the first national historic reserve created by the National Park Service to preserve rural history, island culture, and the area's rare plants. Truly, the island is so large and diverse that there's something for everyone. It's a hotbed for marriage proposals in the Great Northwest.

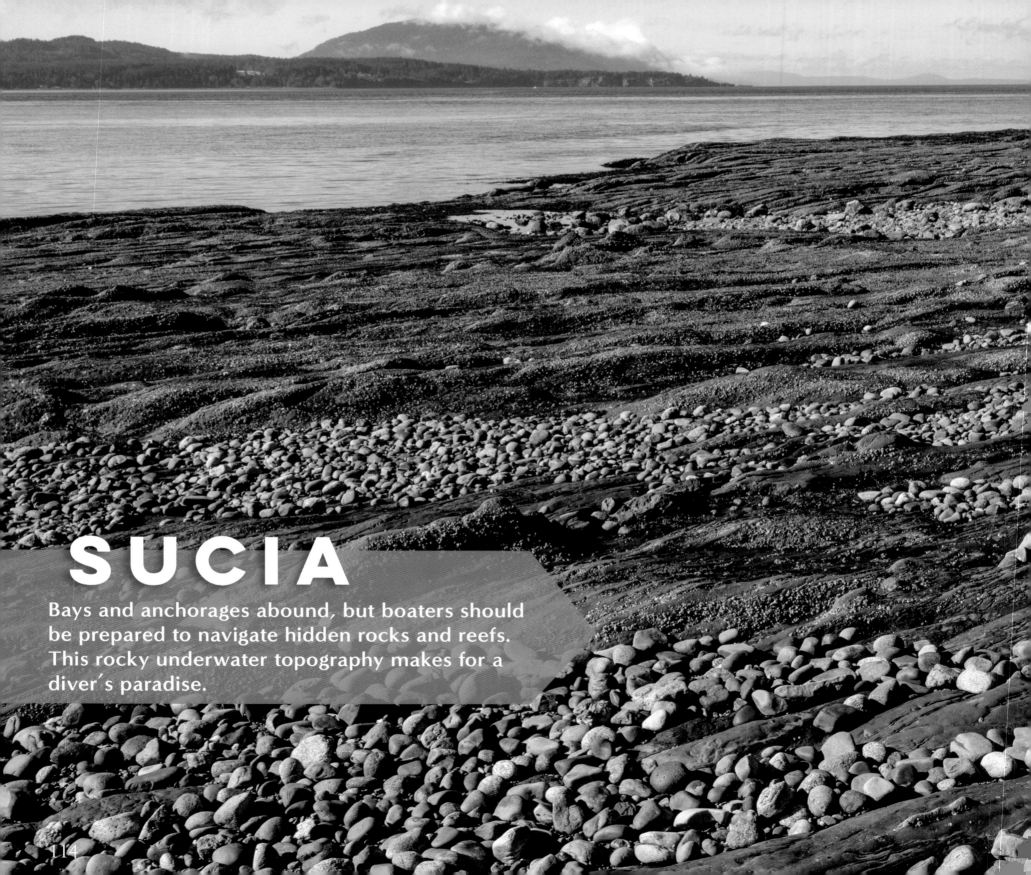

SUCIA

Bays and anchorages abound, but boaters should
be prepared to navigate hidden rocks and reefs.
This rocky underwater topography makes for a
diver's paradise.

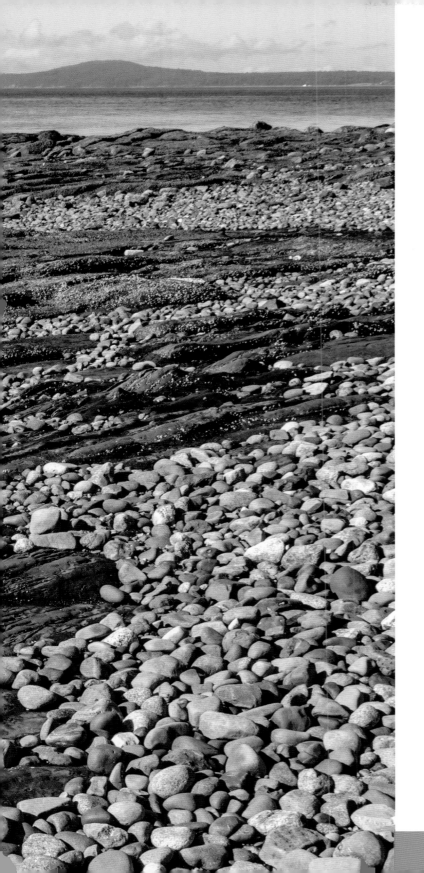

Sucia Island

SIZE: 560 ACRES

LOCATION: STRAIT OF GEORGIA, WASHINGTON

ACCESSIBILITY: BOAT OR FERRY

Shaped like a horseshoe, or perhaps a hand, Sucia Island was named for a Spanish word meaning "dirty" or "foul." It earned that reputation for the reefs and rocks that thwarted boaters trying to get to its shores. Now it's known as the crown jewel of Washington state's marine park system—a popular destination for hikers, fishermen, boaters, and divers. Part of a femur bone from a theropod dinosaur was discovered in a rock on the island in 2012.

CAMANO

Camano Island offers a mellow contrast to the nearby Seattle area. Waterfront activities are particularly popular.

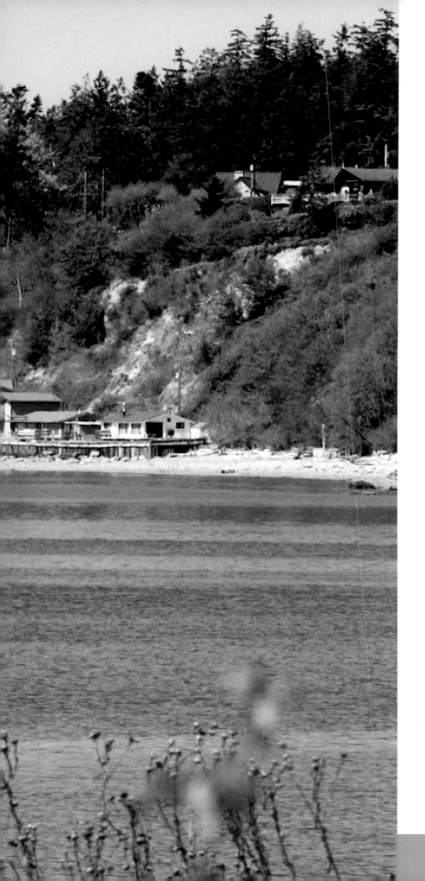

Camano Island

SIZE: 40 SQUARE MILES

LOCATION: ISLAND COUNTY, WASHINGTON

ACCESSIBILITY: CAR, BOAT, FERRY, OR AIRPLANE

Named for Spanish explorer Jacinto Caamano, Camano Island sits mere minutes from the freeway but offers a remote feel for those in the Great Northwest. Hiking, fishing, beaches, and shopping are just a few of the reasons folks make the short trip over the bridge. There are also several fabulous dining options, with seafood (of course) topping the list of specialties. As with its sister island, Whidbey, Camano offers several events and festivals in the warm-weather months.

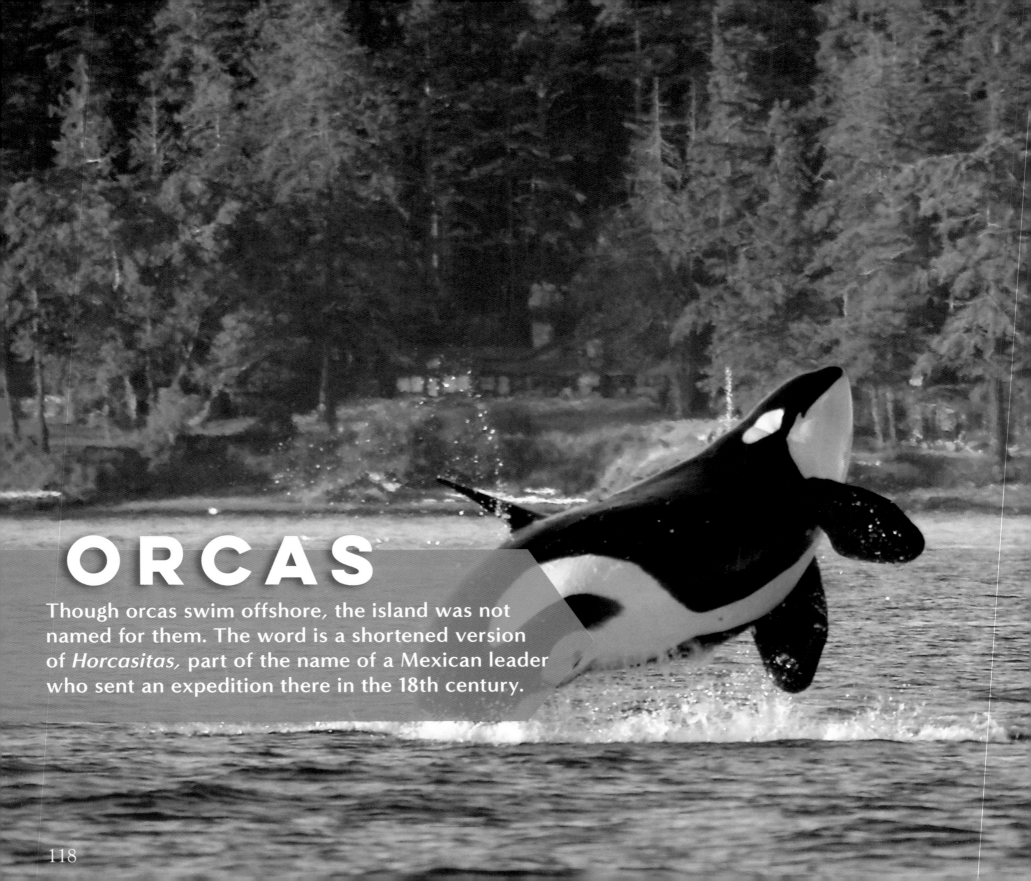

ORCAS

Though orcas swim offshore, the island was not named for them. The word is a shortened version of *Horcasitas,* part of the name of a Mexican leader who sent an expedition there in the 18th century.

Orcas Island

SIZE: 57.3 SQUARE MILES

LOCATION: SALISH SEA, WASHINGTON

ACCESSIBILITY: REGULAR FERRY SERVICE, PRIVATE BOAT, AIRPLANE, OR SEAPLANE

Largest of the San Juan Islands, Orcas features forested hills and rich farmland bounded by over 100 miles of rocky shore. The island seems to have an endless supply of small valleys, inlets, and small bays, giving an impression of opulent seclusion. A population of over 5,000, however, means plenty of places to stay, fresh seafood, and farm to table dining. Kayaking is popular, and inland hiking trails abound. Orcas is also a great whale and bird watching destination.

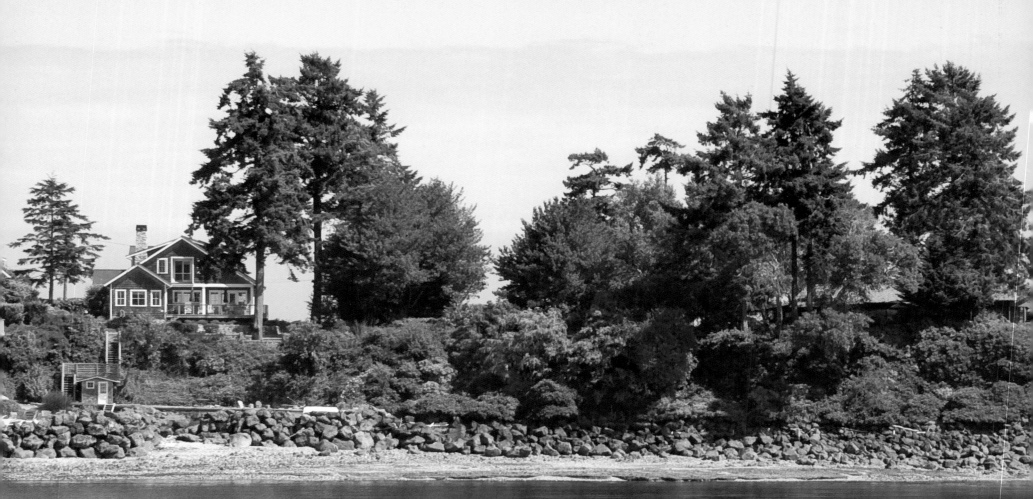

BAINBRIDGE

Secluded residences dot the waterfront. About a third of the island's residents live along the picturesque shoreline.

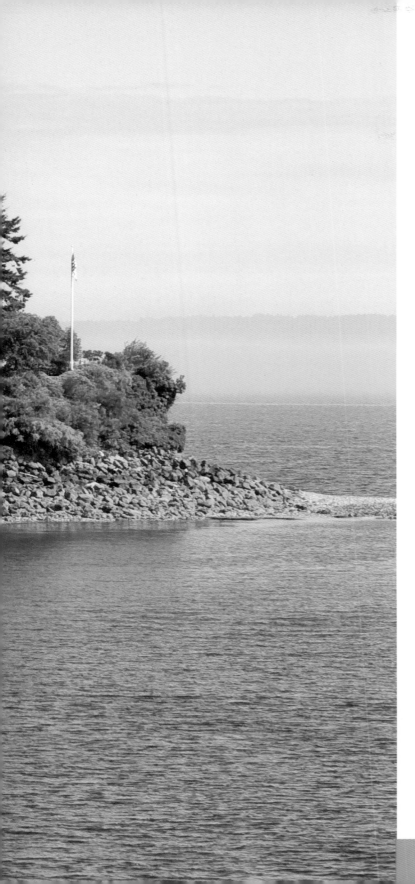

Bainbridge Island

SIZE: 27 SQUARE MILES

LOCATION: KITSAP COUNTY, WASHINGTON

ACCESSIBILITY: BOAT, FERRY, OR CAR

Bainbridge Island is not only a great place to visit. It's been ranked among the best places in the U.S. to live—something more than 20,000 people do year-round. If you're visiting, however, the beautiful ferry ride from the Seattle waterfront offers some of the most spectacular views of the Puget Sound area. The Suquamish people inhabited this island for centuries, but European and Japanese settlers followed. Development has been controlled, preserving vast open space for residents and visitors to enjoy.

ADMIRALTY

The mountains of Admiralty rise to nearly 4,700 feet. Permanent ice fields dot the heights.

Admiralty Island

SIZE: 1,646 SQUARE MILES

LOCATION: SOUTHEAST ALASKA

ACCESSIBILITY: BOAT OR FLOATPLANE

Admiralty Island is one of the 10 largest islands in the United States, but not a lot of people call it home. In fact, brown bears (the densest brown bear population in the U.S.) outnumber humans by about a 3-to-1 margin and are a big reason visitors hop on planes or boats from the mainland to pay a visit. The Kootznoowoo Wilderness also contains bald eagles and black-tailed deer.

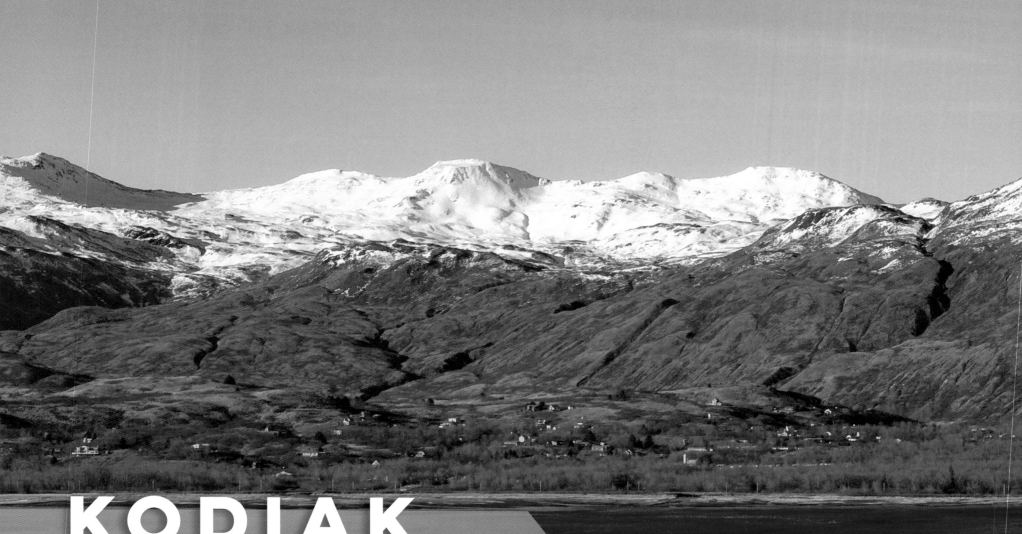

KODIAK

Kodiak's hiking trails offer epic challenges. Its peaks range from 2,000 to 4,000 feet in elevation.

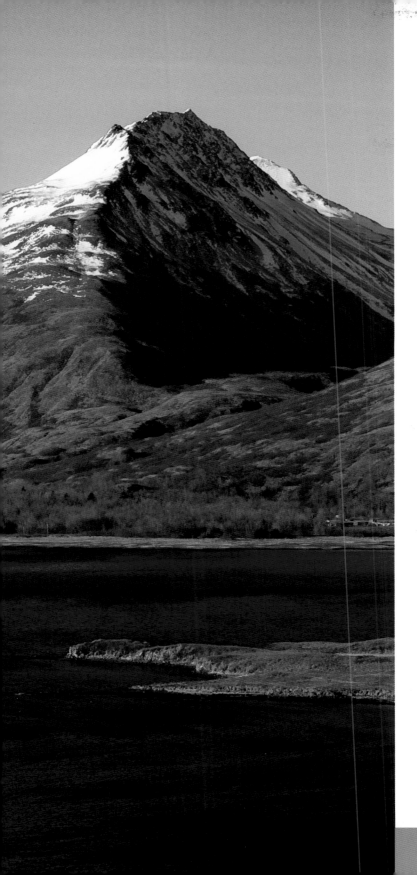

Kodiak Island

SIZE: 3,595 SQUARE MILES

LOCATION: SOUTH OF HOMER, ALASKA

ACCESSIBILITY: BOAT, FERRY, OR AIRPLANE

Kodiak is the second-largest island in the U.S., and a popular spot for visitors to Alaska. Almost two-thirds of the island comprises the Kodiak National Wildlife Refuge. Of course, Kodiak bears—a subspecies of the brown or grizzly bear—roam the land here and are a sought-after attraction for visitors. The largest bears in the world, they can stand more than 10 feet tall on their hind legs. The king crab is also native to Kodiak Island. Harvesting crab is the island's top industry.

BARANOF

Beyond the town lies classic Alaskan coastal wilderness. The lushly forested mountainsides contain more bears than humans.

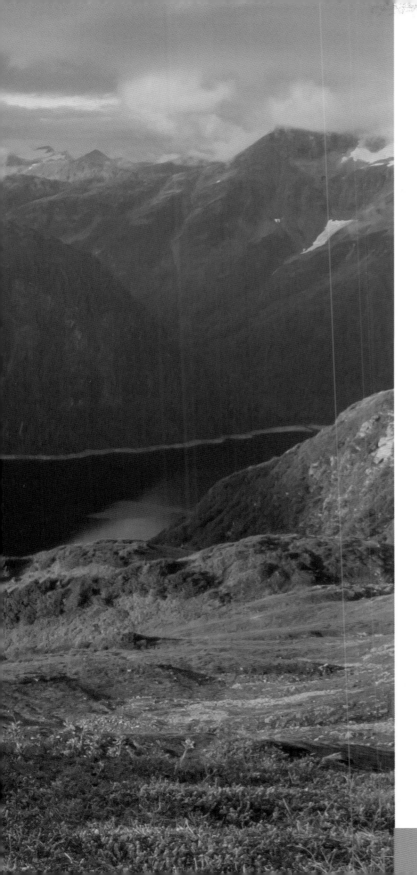

Baranof Island

SIZE: 1,600 SQUARE MILES

LOCATION: ALASKA PANHANDLE, ALASKA

ACCESSIBILITY: BOAT, FERRY, OR AIRPLANE

The smallest of Alaska's ABC islands (along with Admiralty and Chichagof), Baranof is made up almost entirely of the town/borough of Sitka. It was named in 1805 by a captain of the Imperial Russian Navy in honor of Alexander Andreyevich Baranov, who ran the region's fur trade at the time. Much of the forested island (Tongass National Forest) is designated as the South Baranof Wilderness—a great place to see bears in their natural habitat.

UNALASKA

Dutch Harbor, one of the area's few settlements, looks across the bay at the island's rugged mountains.

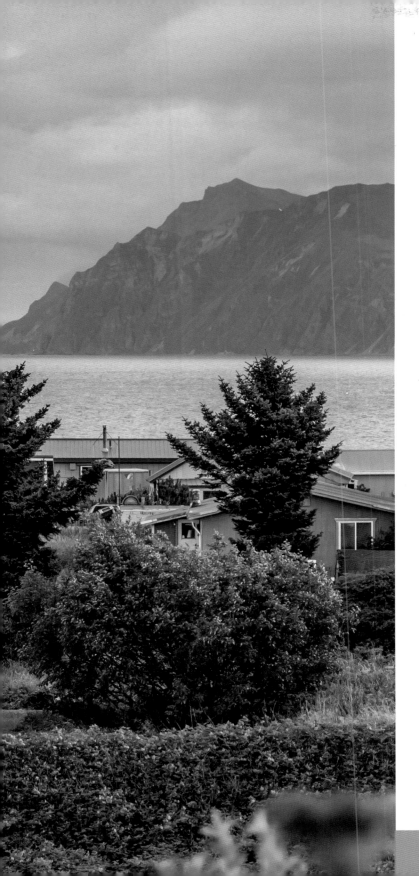

Unalaska Island

SIZE: 212 SQUARE MILES

LOCATION: ALEUTIAN ISLANDS, ALASKA

ACCESSIBILITY: BOAT OR AIRPLANE

The population center of the Aleutian Islands with a few thousand hearty residents, Unalaska is not—as the name seems to indicate—the anti-Alaska. It is Alaska to its core. The name comes from the Aleut *Ounalashka,* meaning "near the peninsula." Dutch Harbor is one of the largest fisheries in the U.S., and home to some of the freshest king crab anywhere in the world. It's a seafaring island unlike any other.

VIEQUES

Caracas Beach, on the southern coast of the island,
provides sheltered, calm waters for beachgoers.

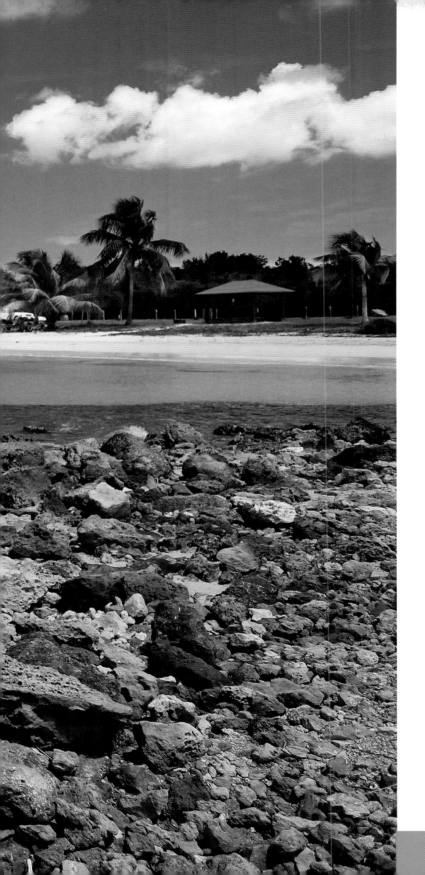

Vieques Island

SIZE: 52 SQUARE MILES

LOCATION: EAST OF MAINLAND PUERTO RICO

ACCESSIBILITY: FERRY OR SMALL AIRCRAFT

White, powdery sand on uncrowded beaches has long been the draw of Vieques Island, located eight miles east of the Puerto Rican mainland. Influenced by more than four centuries of Spanish presence, its blue waters give way to colorful, stucco buildings and a variety of restaurants, each with a distinct flavor and character. Wild horses roam free—a majestic sight—on Vieques, which began welcoming visitors again in 2018 after major hurricane damage in 2017.

ISLA CULEBRA

The island is surrounded by vibrant cays filled with spectacular underwater landscapes. Snorkeling and diving are favorite activities.

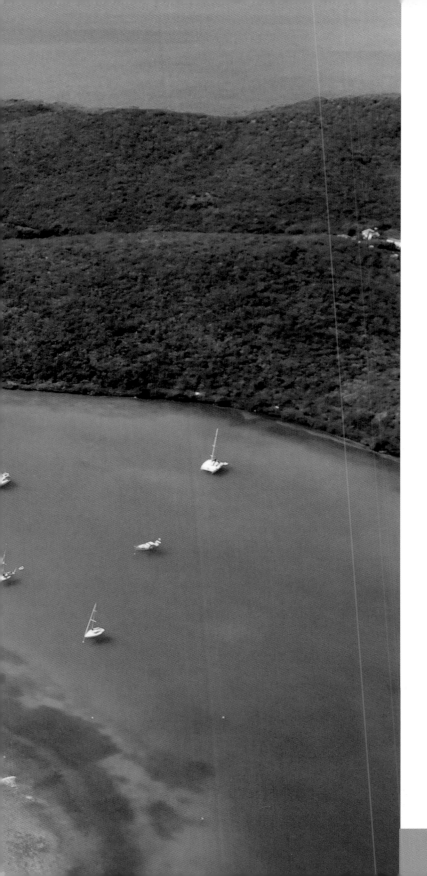

Isla Culebra

SIZE: 11 SQUARE MILES
LOCATION: EAST OF MAINLAND PUERTO RICO
ACCESSIBILITY: BOAT OR FERRY

Isla Culebra sits geographically at the end of the Virgin Islands but is part of Puerto Rico, whose mainland sits some 17 miles away. Often called Isla Chiquita (Little Island), it's Puerto Rico's least populous municipality with fewer than 2,000 residents, but its beaches are among the very best. Flamenco Beach, in particular, has been rated among the best in the world. Some claim that Christopher Columbus was the first European to set foot on Isla Culebra. Much more recently, the island was home to U.S. Navy and Marine bomb testing that ended (to the delight of the locals) in 1975.

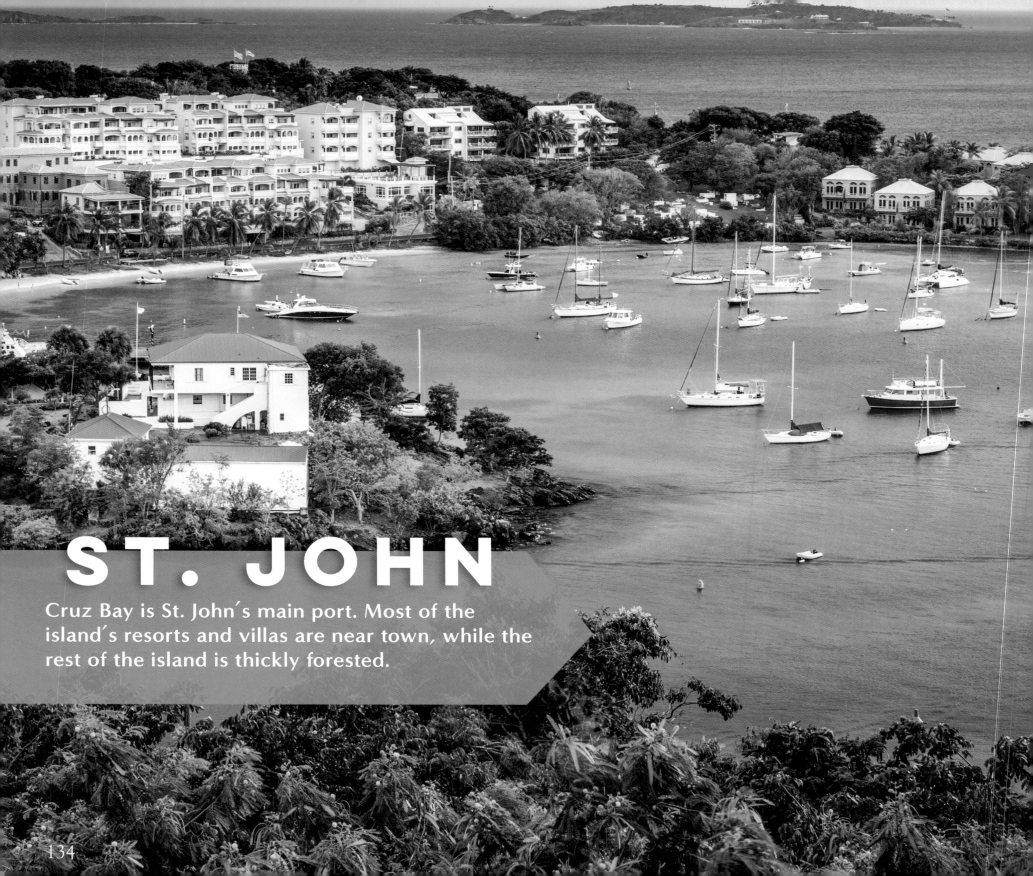

ST. JOHN

Cruz Bay is St. John's main port. Most of the island's resorts and villas are near town, while the rest of the island is thickly forested.

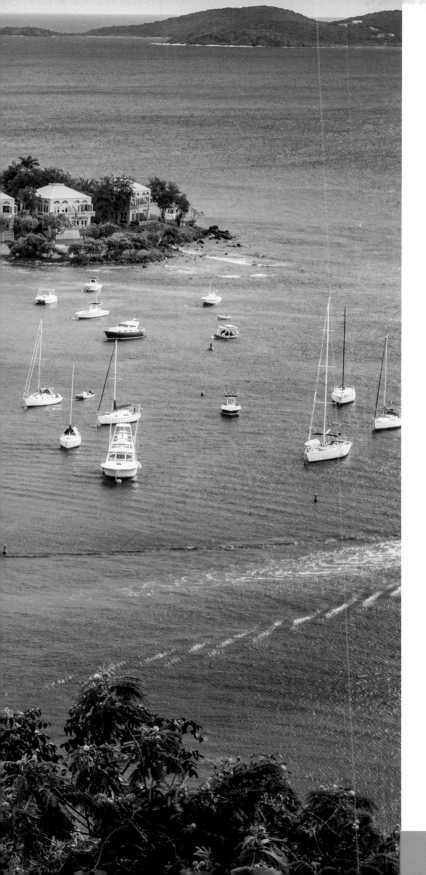

St. John Island

SIZE: 20 SQUARE MILES
LOCATION: CARIBBEAN SEA
ACCESSIBILITY: BOAT OR FERRY

One of the most popular stops for Caribbean cruise ships, St. John is the smallest of the U.S. Virgin Islands but quite possibly the most beautiful. That beauty is largely unspoiled despite the heavy tourism, thanks to the fact that 60 percent of its area is a national park. Much of the island's shoreline, water, and coral reefs are also protected within the park, making St. John's beaches among the very best in the world for snorkeling.

MOLOKAI

The island boasts some of the tallest sea cliffs in the world. Few roads lead to this remote area, but helicopter tours provide awe-inspiring views.

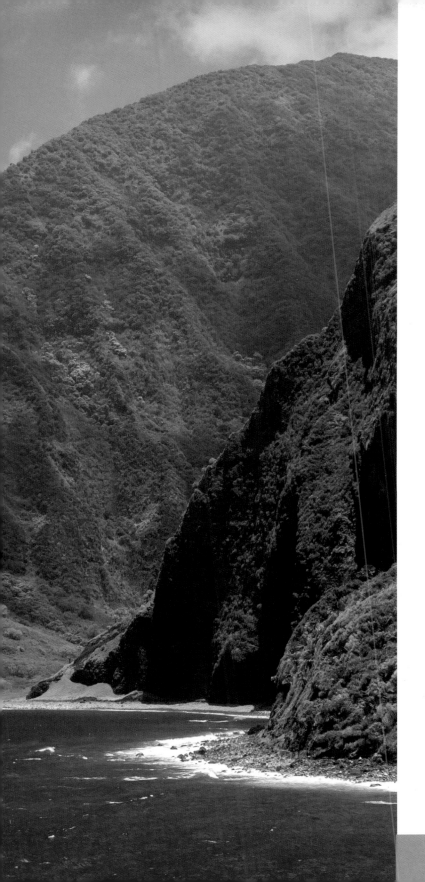

Molokai Island

SIZE: 260 SQUARE MILES

LOCATION: HAWAII

ACCESSIBILITY: BOAT OR PLANE

The fifth-largest of the eight islands that make up Hawaii, Molokai is known as the "Friendly Isle." It also has a historical distinction that doesn't sound quite so friendly. In 1866, there were settlements set up on the island's north coast to quarantine people with leprosy. The settlements remained active for more than 100 years, and are preserved in the Kalaupapa National Historical Park—well worth a visit. In addition to Molokai's rich native Hawaiian history, visitors can enjoy the breathtaking beauty of the highest sea cliffs in the world, its longest continuous fringing reef, and the massive, white-sand Papohaku Beach.

KAUAI

The Na Pali Coast of Kauai has been called the most beautiful place on Earth. Jagged emerald peaks, abundant waterfalls, and secluded beaches provide stunning panoramas.

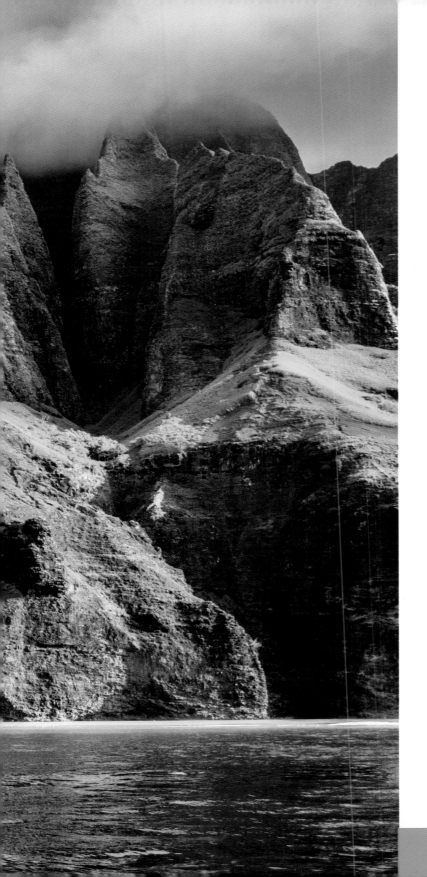

Kauai Island

SIZE: 552 SQUARE MILES

LOCATION: HAWAII

ACCESSIBILITY: BOAT OR PLANE

The accurately nicknamed "Garden Isle" is the fourth-largest of the eight Hawaiian Islands. Kauai is both the oldest and the northernmost island of Hawaii, and its rocky cliffs, mountain peaks, and lush, green valleys are as inviting to the eye as any scenic destination anywhere. This five million-year-old paradise attracts more than one million visitors every year. They flock from all over the world for any number of reasons, including relaxing on pure, white-sand beaches, exploring state parks and waterfalls, and kayaking the beautiful Wailua River.

AMERICAN SAMOA

The harbor town of Pago Pago is surrounded by lushly wooded, steep mountains. Spectacular views of the downtown area can be had from the summit of Mount Alava.

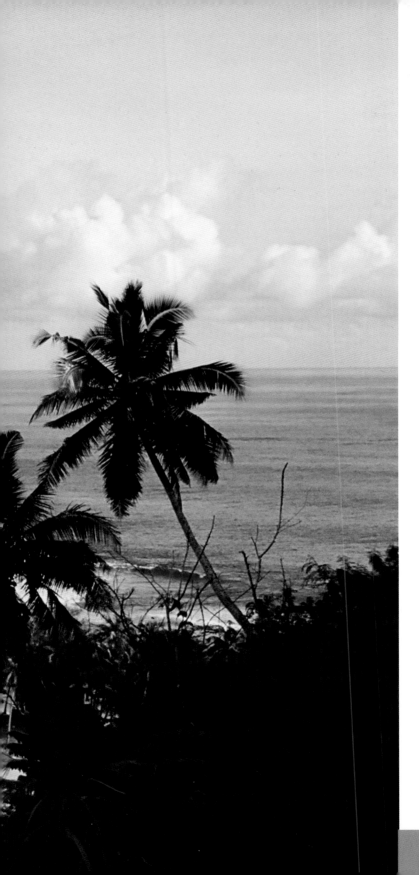

American Samoa

SIZE: 77 SQUARE MILES

LOCATION: SOUTH PACIFIC

ACCESSIBILITY: AIRPLANE OR SHIP

Located just southeast of Samoa and not far from the equator, American Samoa consists of five main islands and two coral atolls. It's not hard to see the allure of this tropical spot that sits about halfway between Hawaii and New Zealand. Polynesian culture has been preserved in its Samoan villages, and much of the landscape—volcanic peaks, tropical rainforests, and magnificent reefs—remains untouched, as if one were visiting 3,000 years ago. Fabulous beaches and rich World War II history are among the many draws of American Samoa.

NORTHERN MARIANAS

Rota is located at the south end of the U.S. portion of the island chain. Vivid coral reefs lie offshore, making diving a popular activity.

Northern Mariana Islands

SIZE: 77 SQUARE MILES
LOCATION: NORTHEAST OF GUAM, PACIFIC OCEAN
ACCESSIBILITY: AIRPLANE OR BOAT

The Mariana Islands are part of a submerged mountain range that stretches from Guam almost to Japan in the Pacific Ocean. The northernmost 10 islands are all volcanic and uninhabited, while the southern islands—Rota, Guam, Aguijan, Tinian and Saipan—are comprised of coralline limestone, with all but Aguijan inhabited. The indigenous Chamorro culture is evident all around the islands, whether on the pristine white sand beaches of Saipan (where many visitors start), or the spectacular cliffs or hidden villages that many of the Mariana resorts can arrange hikes to see.

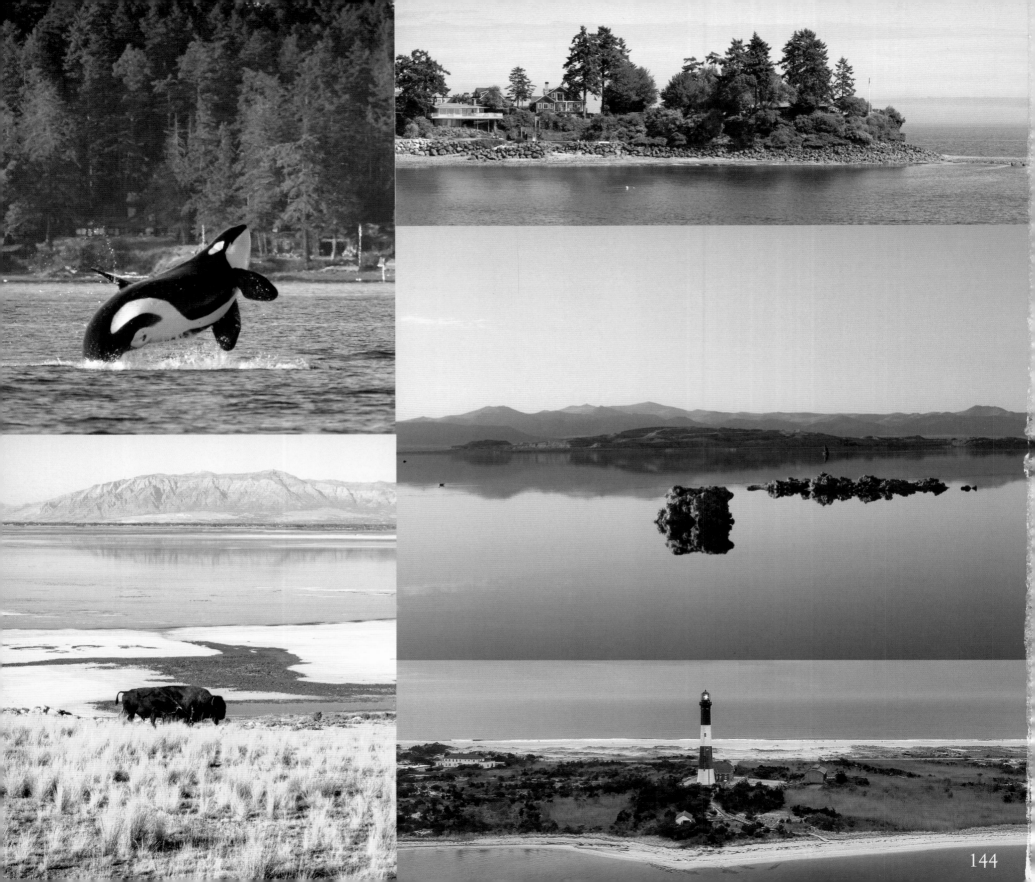